Myths of Modern Art

MYTHS
of
MODERN ART

Alberto Boixados

UNIVERSITY
PRESS OF
AMERICA

Lanham • New York • London

Copyright © 1991 by

University Press of America®, Inc.

4720 Boston Way
Lanham, Maryland 20706

3 Henrietta Street
London WC2E 8LU England

Library of Congress Cataloging-in-Publication Data

Boixadós, Alberto
Myths of modern art / Alberto Boixadós.
p. cm.
Includes index.
1. Arts, Modern—20th century. I. Title.
NX456.B64 1990 700'.904—dc20 90–42179 CIP

ISBN 0–8191–7952–3 (alk. paper)

 The paper used in this publication meets the minimum requirements of
American National Standard for Information Sciences—Permanence
of Paper for Printed Library Materials, ANSI Z39.48–1984.

"Today there is a peculiarly modern reward that the avant-garde artist can give his benefactor: namely, the feeling that he, like his mate the artist, is separate from and aloof from the bourgeoisie, the middle classes . . . the feeling that he may be *from* the middle class but he is no longer *in* it . . . the feeling that he is a fellow soldier, or at least an aide-de-camp or an honorary cong guerrilla in the vangard march through the land of the philistines."

TOM WOLFE
"The purple decades"

ACKNOWLEDGEMENT

I should like to acknowledge my friends Reed and Roxalana Armstrong, Ethel Gray, Patricia Bozell, Mariano Castaneira and Richard B. O'Keefe, without whose assistance this book would not have been possible.

Contents

Foreword

by Father Vincent P. Miceli

Christian civilization is in its death throes. A hurricane of revolutionary metaphysical and moral heresies is sweeping Christian nations into accepting neo-pagan ideas and hedonistic morals. This revolt against Christian truths has produced the free-thinking and sexually abandoned society, in hot pursuit of a temporal utopia. The new gospel is that "man has come of age" and can no longer believe in the artistic and religious traditions of his classical and Christian ancestry. These ideals are simply incredible.

Yet this updated man is called upon to believe far greater secular superstitions. As a result, he has, in the millions, joined myriad forms of cults and occultism in a vain search for a supernatural society, not even realizing that he abandoned the only possible one—the one founded on Christ—when he fled from the Christian culture of his forebears. Millions are submitting to the new religions, though these degrading myths and their unnatural liturgies are far less beautiful, far less sublime and less satisfactory than the magnificent cultural heritage that is being so flippantly dicarded.

It should come as no surprise, then, to see that the post-Christian paganism has corrupted the arts. Alberto Boixados's book is a brilliant, somber exposé of this corruption. The ugly, the uncivil, the irreverent, the violent, the obscene, the ideological, the hateful has permeated the arts—sculpture, painting, literature, drama, music, poetry, dancing, and rhetoric. These are founded on the lie that there is no objective truth,

no objective good, no objective beauty, no objective heroic holiness. The same lie teaches that values do not come from God nor from his creation and revelation, but from the whims of man. These arts, plus the art of politics or self-government, have been secularized and vulgarized. Whatever is new and revolutionary is considered good art. The modern iconoclasts are ignorant of the inspiring transcendental aspects of beautiful art—its unity, truth, and goodness. Even pre-Christian pagans—Plato, Artistotle, sculptors and playwrights—often produced the magic spell of beauty. They did this because they submitted to the truth, unity, and splendor found in creation and in man, the wonder of God's creation.

There is a profound sadness in the criticisms leveled by the author against the new myths. He deplores the fact that Marxist writers are given literary prizes. The propaganda use of their works in destroying existing societies in order to establish class warfare is rewarded. Concomitantly, the artistic values of good literature are simply ignored. The youth subculture with its dirty jeans, long hair, sexual gyrations, and electrified noises earns millions of dollars from hundreds of thousands of frenzied youth who corrupt the art of music. Even the talent of a Picasso and other moderns, so politically and pornographically oriented, is calculated to create irreverence and hostility for Christian values. There seems to be a death-wish in the collapse of the arts. Their salvation is sought in revolution, not in revelation, which is why they are full of violence, pornography, and suicide.

Go where you will in this book, you will find Alberto Boixados an excellent guide and analyst of the artistic malaise. He exposes the theological and philosophical diseases causing the evils in our subculture. Disorder, ugliness and hate become one in the art of a godless society, because they are one in the satanic society which they emulate. On the other hand, order, beauty and joy become one in the truly Christian society, because they are one in the family of the Holy Trinity, which is emulated by the communion of saints.

Preface

by Thomas Molnar

Alberto Boixados brings together recent products of a variety of the arts, each showing how far art has degenerated in this century. As I write these lines, the contrast between what art used to be (for example, architecture) and what the present ideal of its practitioners is (for example, music) is vividly exemplified by two texts on my desk. One is a Rizzoli volume, *The Monastic Realm* (by Oursel, Moulin and Gregoire), with illustrations of medieval stone—that is, what God-believing architects and sculptors could do when inspired by a power higher than man's; the other is a quotation from composer Pierre Boulez (press conference, 1974). Alas, I cannot present the first item, the volume, except in the few and inadequate words above; the quotation is easier to transcribe:

"Our age is one of persistent, relentless, almost unbearable inquiry. In its exaltation it cuts off all retreats and bans all sanctuaries; its passion is contagious, its thirst for the unknown projects us forcefully, violently into the future; it compels us to redefine ourselves, no longer in relation to our individual functions, but to our collective necessity. Despite the skillful ruses we have cultivated in our desperate effort to make the world of the past serve our present-day needs, we can no longer elude the essential trial: that of becoming an absolute part of the present, of forsaking all memory to forge a perception without precedent, of renouncing the legacies of the past to discover undreamed of territories."

Boulez speaks eloquently—about an abjection: the denial of

the past that lives around us, and the justification of the "unbearable inquiry." If there is such a thing as the mystique of mindlessness, then Boulez, in spite of choice words, has reached it; for in art, as in every endeavor of man from politics to poetry, reason and judgment are included. This is what the modernity of Boulez denies, although Pascal saw in reason (not in dry rationalism!) man's distinguishing sign in facing the silent universe, and Paul Valéry admitted that the first line of a poem may come from God, but that the rest is human effort, chiseling, eliminating, correcting. Thus we are not as impotent vis-à-vis present and future as the quotation pretends.

The reference to Boulez and to atonal, unmelodious, mechanically produced music ("aurally stunning and stunting," a critic who opts for Bach and Mozart says) is apposite in this Preface to Alberto Boixados's book. Art is neither an uncontrolled emotional process, nor a utopian endeavor attempting to build a "better world," a "world without precedent," as Boulez implies. For this reason, the artist is not an exceptional being before whom we must stand in greater awe than before, let's say, a physician, a scientist, or an artisan. Modern art—that is, the ugly and offensive in it—was born when artisanship separated itself from its duties to fellow humans: patrons, churches, palaces, or simply admirers of beauty. The artist at that point was separated from society, became a "genius," a misunderstood and darkly brooding giant, forming with his fellows a special class of heroes and supermen. That was the moment when art for art was born, and the artist took off for lands unknown. He could now do anything, rival and surpass God; he became what every little college student in art departments calls himself, a "creative" person.

The artist as a misunderstood genius is now exempt from the double task of understanding mankind—that is, the segment of it which is his public—and the world of objects, shapes, harmony, and storytelling. He is given license to produce his own world, his own screeching noises, his own meaningless objects and canvasses. Who would dare judge superman? Not the stu-

pid crowds at the latest exhibit, not the snobbish art patrons, not the dealers out for a fast million bucks. Thus I do not quite agree with Alberto Boixados who sees subversive intent where I find the unnatural and unprofessional emancipation of the artist from tradition, from society's links, from the canons of beauty. Yet I join the author's judgment that political and moral subversion became easily grafted on the work of demolition that the new artist regarded as his duty. Subversion—for what else can one call it?—when the magnificent perspectives of a city like Paris are blocked by ugly skyscrapers, when a glass pyramid is allowed to disrupt the age-old harmony of the Louvre and the Tuileries, when a Centre Pompidou is built in an old and noble *quartier,* disfiguring its streets and soft skyline.

It is a special kind of subversion, theological in its roots and political in its purpose. Sartre once declared that society today is so unjust that artists should abstain from producing beautiful things. There you have it: the pseudo-artist or writer who speaks and works like a social engineer, an ideologue, a demiurgos, while the true artist, even the Renaissance egotist like Cellini or Michelangelo, humbly submitted to the beauty of past ages, and the almost nameless builders of cathedrals and Cistercian abbeys adored God in stone, in glass, and in the architecture of light. On the face of it, from Bach to Boulez, from Rafael to Jackson Pollock, from Milton to Mailer, a language, a syntax have been lost; in truth, the sense of the sacred was lost, the conviction still so alive for Brahms, Baudelaire, and Van Gogh, that the work of art mediates the transcendent reality to the word of man. The beauty of art is a reflected beauty, and when the artist is encouraged to seek "liberation," he confuses his lines, his words, his tonality, his volumes. Not to mention the fact that he succumbs to the temptation of alienating his freedom: to party politics, to ideologies, to temporary fashions and enthusiasms, and of course to wealth and the adoring masses.

Alberto Boixados brings to these subjects a great deal of eru-
dition, perspicacity—and indignation. No "value-free" writing
on art is possible; aesthetics is related to the ethical, and be-
hind style there is always a worldview. It is safe to predict that
the author's thesis will be dismissed by the self-appointed so-
phisticates; he will be esteemed and recognized as one of theirs
by the genuine lovers of art, a race, fortunately, that will never
become extinct.

Introduction

"The artist is not a special kind of man; rather, each man is a special kind of artist," Delacroix liked to say. That is, the artist is not only a creator but a receiver, since no matter his social or spiritual condition, man will always respond to some form of art.

An artist is not necessarily strange or eccentric; on the contrary, he is on the whole quite commonplace. Certain artistic eccentricities are often adopted for a nonartistic purpose.

Man cannot escape his cultural heritage, for he lives within a society, whether or not it obeys or denies the artistic vision. Man, for instance, dwells in houses built according to certain patterns or ideas; listens, willy-nilly, to music or to what passes for music; reads magazines and books; goes to the movies or the theater; watches television—is constantly besieged by sounds or objects which he finds distasteful. It is impossible, that is, for him to escape the avant-garde art which he finds not only in the art galleries but also in public offices, waiting rooms and consulting rooms, and even in his own home.

This fluid and pervasive artistic world is constantly acting upon a man's sensibility and, therefore of course, on his mind.

In the various periods of history, the major arts—painting, music, letters, architecture, sculpture—have expressed a particular view of the cosmos, of God, and of man himself. Every artistic work, that is, conveys explicitly or implicitly its own conception of philosophy and religion—positive, negative or a combination of both. This artistic world, imbued with religious

1

or aesthetic overtones, tends to propel the soul along unsuspected paths, which ineluctably affects the social order.

But artistic activity is not totally governed by the reigning guidelines of a given historical period; there are always individuals or groups who pursue anachronistic ways, and as a result they have little influence in their time. Art, consequently, is important in the education of the child, the man of the future, because the child in his physical and spiritual development must train all his senses to a creative communion with sounds, colors, textures, and consistencies; he must, in a word, be in communion with the essential diversity of nature in order to channel his creative energies and make his moments of leisure fruitful. A gradual maturing of the spirit should, moreover, go hand in hand with the skills acquired through contact with the real.

Thus, by a natural progression, the child comes to understand that, as the critics Henry and André Charlier suggested, "art consists in contriving that rhythm be expressed in a substance—whether of color, stone, sound, or word—without compromising its immaterial essence and without the least loss of its freedom."[1]

Whether the child understands it or not, through art, he can in time not only channel his feelings and intelligence but also his spiritual being, which will begin to move in the realm of symbols. And this still only hints at the true importance of the subject. It has been argued that the world of art enjoys full autonomy, unhampered by social or political restrictions. This is true at the purely aesthetic level, but the relationship of art with culture and history cannot be disregarded.

The following pages explore certain trends in our contemporary artistic culture, our painting, our music, and, in more detail, our literary world.

1. H. A. Charlier, *El canto gregoriano,* Ed. Areté, Buenos Aires, 1970, p. 47.

CHAPTER ONE
Painting

The most advanced movements in painting today do not even attempt to reproduce reality; rather, they represent the interplay between colors and tensions.

At the beginning of the century, Wassily Kandinsky broke the last remaining contact with the sacred in art, though the tradition retained the respect of some contemporary progressives. "Christian faith in the hereafter," he contended, "paradoxical as it may sound, was represented in medieval times by figurative art forms." But, he believed, only atheism can open the way to antitraditional creativity.

Religion was the barrier that prevented the absolute abstraction of the image. Kandinsky also explains how the impressionist vision first attempted to discover absolute painting. While looking at Monet's canvas entitled *The Haystack* Kandinsky felt that it lacked a thematic object. It acquired power and a stupendous magnificence. A painting exists not because of a given object but because of its pictorial qualities and the vibrant experience it transmits.

Following suit, the painter Georges Mathieu went so far as to say: "A liberation from all previous aesthetics should be launched. An aesthetic art of the conscience must replace the conscience of the aesthetic in art," and he added, "We are at the dawn of a new art that will loose unimaginable processes, a new art that will create a new man." As far-fetched as this may sound, it contains a great truth, for art has enormous

powers of persuasion—a type of persuasion that illuminates the political and religious spheres.

An observant visitor in Mexico will appreciate the influence that painters like Ribera and Siqueiros exert on the spiritual life of the people. Through their imagery these painters have kept alive the anti-Hispanic feelings that all Mexicans evince on the surface, though underneath the Mexican soul is the most Spanish of all Latin American people. The murals of these painters—in the Ministry of Education, the Palace of Justice in Cuernavaca, and many other places—constantly feed this anti-Christian and anti-Hispanic prejudice. To counteract these destructive forces, one must reach back to the source of historic truth.

A brief inspection of the pictorial arts and their political ramifications is best achieved by quoting from an article by the renowned Spaniard, Joaquín García de la Concha: "The contemporary Spanish genius, Pablo Ruiz Picasso, led the vanguard of the revolution in the plastic arts. He was a monster of demolition. Never before has there existed anyone with his capacity for destruction. He was the greatest revolutionary of the plastic arts of all time."[1]

He destroyed through his painting and demolished through his writing; he promoted the revolution by his public declarations and in his private life. A good example is an article by Picasso himself written in 1963 for the magazine *Le Musée Vivant:*

"When I was young, like all young people, great art was my religion; but as the years passed, I realized that art as conceived up to the end of the 1800s was finished, moribund, condemned, and that the so-called artistic activity for all its prosperity was nothing but a multifaceted manifestation of its own death throes. People today are increasingly indifferent to painting, sculpture, poetry; contrary to appearances, people have embraced something quite different: wealth, machines, scientific discoveries, the conquest of natural forces and of the world. We no longer feel that art is the vital spiritual necessity it was in the past.

1. Joaquín García de la Concha, manuscript in author's possession.

4

"Many of us continue being artists for reasons that have very little to do with real art, but rather for the sake of imitation, for nostalgia of tradition, because of inertia, love of ostentation, luxury, intellectual curiosity, to be fashionable, or by calculation. Such artists survive because of habit, snobbery, the recent past; but the great majority of artists in all the fields of art lack a sincere passion for art, which they consider a pastime, a relaxation, an ornament.

"The new generations, lovers of technology and sports, being more honest, cynical and brutal, will gradually abandon art altogether, relegating it to the museums and libraries as an incomprehensible and useless relic of the past. The moment the arts cease to feed the best minds, the artist will deploy his talents in all sorts of experimentation with new formulas, stray fancies and fantasies, and resort to every intellectual chicanery. People no longer seek consolation or exaltation in the arts. And the refined, the rich, the idle, the purveyors of quintessences look for the new, the unusual, the original, the extravagant, the scandalous.

"For my part, from 'cubism' and even further back, I have humored these gentlemen, these critics, with the numerous extravagances that have popped into my head which, the less they understood, the more they admired.

"Amusing myself with these games, the squiggles, the jigsaw puzzles, the riddles and arabesques, I quickly became famous. And celebrity for the artist means sales, commissions, fortune, wealth.

"Now, as you know, I am famous and rich. But when I am alone with myself I have not the courage to consider myself an artist in the grand old sense of the word.

"There have been great painters like Giotto, Titian, Rembrandt and Goya. I am nothing but a public buffoon who understood his times. Mine is a bitter confession, more painful than it may seem, but it has the merit of being sincere."[2]

Thus the confession of a man with a clear vision, who was

2. P. Ruiz Picasso, *Le Musée Vivant,* L'Association des Amis des Musees, 1963, No. 17–18. Copy supplied by Joaquín García de la Concha.

conscious of what art should be, of its profound mission. The confession embodies, too, a most tremendous human tragedy— submission to the temptation to subordinate art to earthly glory and political ends.

But Ruiz Picasso was aware that art, great art, had existed, and could do so again.

The purpose of art is to reveal what is hidden from our basic senses, not to escape reality, but to make it intelligible and fully comprehensible by symbolic means. In what sense is the abstract in all art?

The human spirit, incapable of apprehending the totality of anything, needs to extract, choose and select the essential aspects of reality in order to represent them artistically. This, then, is abstraction.

This is not to imply that every artist seeks his truth and constructs it from his own being. This would demolish the foundations of intellectual and artistic life. Rather, in order to communicate his thoughts through art, man must use a kind of selectivity that is dictated by the materials he employs to express himself—whether stone, wood, color, sound, or words. By doing so, the mind penetrates deeply into reality, the thought is always expressed symbolically. This truth should be constantly cherished.

By the use of symbols, we inscribe the spiritual on the material—which it transcends—without sacrificing its immaterial essence and its freedom.

One of the ultimate degrees of abstraction that an artist can attain is the interaction between the soul and the body. There is a real analogy between the quality of the soul and the shape of the body, since the soul is the origin of the body. A still figure, rather than violent movements, best demonstrates the internal tensions of the interaction of the soul in the body.

Facial expression, moreover, does not reveal so much about a face as the configuration of its parts, which hint at and even point to the presence of the soul. This caused H. A. Charlier, the critic, to remark that Rembrandt was more metaphysician than psychologist.

The story of Picasso is, in a way, the story of a quest for this

6

preeminent quality. This painter, leader of the avant-garde school, was until his cubistic adventurism trying to express himself truly and honestly through form. His early paintings were surprisingly well conceived, as, for example, his *Science and Charity,* painted while he was still a student in 1897, which received an honorary mention in a nationwide contest.

"But," according to Charlier, "when Picasso realized that he lacked the ineffable creative faculty, he began to rely on chance and instinct. He renounced the search for truth and succumbed to portraying the dishonest and farcical, although he would occasionally produce a drawing worthy of a great master.

"Picasso is disturbed, almost agonized by the exact degrees of abstraction required to achieve a perfect design, but his error is obvious. There is no need to eliminate successively; it is rather a matter of selection, the selection of a particular reality replete with its life, its drive, its unpredictability."[3]

Picasso should have separated the accidental from the essential, for this is the measure of the mastery of abstraction. And herein lay the creative choice of Picasso. In his Blue period he drew far better than during his Belles Artes school days, for he aspired to formulate a style.

In his canvas entitled *Life,* Picasso demonstrated his understanding of spontaneity and of how to achieve the necessary tension of forms, wherein he had no equal; a composition needed one guiding line, not two or four.

But when things do not fall into place the "successive elimination" of lines—the "stylization of abstract production"—systematizes nature, that is, forces it to fit into an ideological slot. And when Picasso did this, he was able to effect a revolution—the ideology of the Fine Arts.

As a result, everything becomes arbitrary, unhinged from the reality which the artist is obligated to penetrate and reveal. And art becomes a mere game, though a dangerous game because it is ruled by revolutionary spirits who wish to trans-

3. Henri Charlier, *Le Martyre de L'Art,* Paris, Nouvelles Editions Latines, 1957, pp. 35–37.

form human nature, and who under the guise of pure painting, pure thought, and pure justice, deny original sin.

It echoes exactly the line of thought at the conclusion of Leon Trotsky's *Literature and Revolution,* an interesting and revealing book, in which he discloses what man will be like in the Communist world.

"Man will strive to become the master of his feelings, to raise his instincts to the peak of his consciousness, forcing them to become sheer conductors of his will, leading to the threshold of his consciousness in order to reach, through them, a higher socio-biological level, or if you like, make him a superman.

"Better put: in the process of cultural edification and self-education, the Communist man will develop to the utmost of his power the vital elements of the arts. Man will become incomparably stronger, more prudent and intelligent, and more refined. His body will become more harmonious, his movements more rhythmic, and his voice more musical; his whole being will become dynamic.

"The average intelligence will reach the level of an Aristotle, a Goethe, or a Marx. Upon these summits new pinnacles will rise."

Further comment is unnecessary, other than to point out that this utopian dream typifies the attitude of the autonomous man who would deify himself and give renewed life to the original act of rebellion.

Picasso does not state this as clearly as Trotsky but many of his expressions and actions point to the same line of thought. He says, for example, "The artist should find a way to convince the public of the veracity of his lies." Picasso's skillful brush could make it amusing, but when the trick is repeated ad nauseam by lesser talents, it becomes tedious and almost inconceivably ridiculous.

A United Press news dispatch from Albuquerque, New Mexico, which appeared in the Argentinian daily *La Prensa* on January 5, 1966, is a fair example of this phenomenon:

"Three painters have embarked on a marathon of creativity.

Their canvases, which follow the purest concepts of abstract art, sell for around $4,000.

"Two gorillas and an orangutan will in this way repay the community which had the honor of accommodating them in the cages of the local zoo for their keep.

"Henry, the orangutan, prefers the finger-painting technique; that is, he spreads the paint with his fingers, going from one canvas to another in a fit of inspiration. His two companions prefer the 'stomping' technique and, like true quadrupeds, paint with four hands.

"The three simians cost the zoo $15,000 and the directors feel that as painters they will easily earn this much and more. Moreover, a fourth monkey, whose artistic abilities are still unknown, is expected.

"The paintings, as good as that of any avant-garde painter's work, are exhibited in the lobby of a local bank." No comment.

Nonfigurative painting, the critic Michael Zahar asserts, should be confined to its rightful place; that is, in the framework of elemental decorative art.

The thought was echoed by André Malraux who, near death, commented: "During the last thirty years I discerned two languages which I heard simultaneously. One was that of appearances, of the masses, rather like what I saw in Cairo—the language of the ephemeral, the transitory. The other one was that of truth—the language of the eternal and the sacred. Art does not reveal that nations depend on the transitory, on their houses or their furnishings, but on the truths that it was given them to create. All sacred art is opposed to death, because it does not adorn civilization; rather, it expresses it in accordance with the supremacy of its value."[4]

This is why the so-called abstract painters, far from seeking abstraction, shrink from the difficulties of abstracting from the concrete those qualities required for the profound insight which would result in a true plastic symbolism. Where can the abstract be extracted if not from the concrete? And what inter-

4. André Malraux, *La Prensa,* Buenos Aires, Nov. 24, 1976, p. 2.

est does the abstract hold if unrelated to the concrete? The soul is concrete and gave form to our body. If the means of knowing the soul is abstraction, Charlier claims, then abstraction is the concrete of the spirit.

It is obvious that we cannot separate what is united; but in the plastic arts the concrete and the abstract are revealed together, that is, what the spirit perceives of them. This is not a disadvantage to thought—quite the contrary. Hence, the measure of the greatness of a painter is the degree to which he possesses the power to concretize, through abstraction, the sublime internal tension of being. Now perhaps we can appreciate Picasso's admiration for Rembrandt, Giotto, Titian, and Goya, and the profundity of his confession.

German Bazin, the noted artist and curator at the Louvre in Paris, has formulated a theory on Picasso which is thought-provoking since it digs deep and plumbs levels seldom reached. Speaking of pre-Columbian art in America he says:

"In the course of the civilizations of art, we have seen that the West was the least affected by the diabolic in art.

"This lack of affinity in the West for plastic demonology makes its sudden emergence in our time far more preoccupying and disturbing.

"The real face of the Prince of Discord appeared like a thunderbolt at the turn of the century among the festivities of the populace who drunkenly celebrated the dawn of a new age of progress which they believed would bring man ultimate happiness.

"Satan took the occasion to reveal himself in a borrowed black mask, as seen in the *Demoiselles d'Avignon* by Picasso, whose grinning maws announced the bestial licentiousness which a few years later would spread throughout the world. At the time, it caused no alarm; the phenomenon was believed to be simply an artistic game, a puzzle. Twenty years later, the prophetic Spanish genius, stimulated by a civil war which was destroying his country, created *Guernica* (1936). This massacre of the human figure in painting prefigures the frightful criminal assault that man would soon perpetrate upon himself.

"These more recent figures by Picasso, which provoked such

10

scandal, carried the mark of diabolic genius, this time attacking the masterpiece of creation itself. The human figure, fractured as if by an explosion, is reconstructed bit by bit by no law other than that of incongruity. The resulting sarcastic jigsaw puzzle is a typical expression of chaotic discontinuity, which abhors unity and seems to be the essence of the demonic style. I know that Picasso later recanted, explaining that in these works he was guided not by beauty, but by a different sentiment.

"But, is this not precisely the diabolical claim? 'Quis ut Deus? [Who like God?],' cried St. Michael as he vanquished the Prince of Pride with a ray of light."[5]

It is difficult to ignore these words by Bazin. Although the modern world denies the transcendental side, the intellect should be allowed to speculate on the validity of Bazin's statements, because the survival of our culture may depend on it.

All the foregoing does not invalidate the nonfigurative arts. They have always existed. Generally speaking, architecture does not imitate or represent anything, yet the human figure is present in it as in all nonfigurative art. There the human body is used as the unit of scale of construction. Contemporary nonfigurative artists refuse to deal with the concrete. And this is their Achilles' heel.

For nearly all recent artists, newly liberated from the conventions that had ruled their artistic productivity, any material, any medium of any possible use to painting is admissable. This situation, as Heino R. Möller states in his *Art as Ideology,* leads to the elimination of consent, the disappearance of any ties with the concrete, and drastically reduces the traditional, iconographic methods as well as the structural composition.

A simple painting which indulges in experimentation, reduction, or the stylizing of designs, takes considerably less time and technical expertise. The increased output satisfies an ever-growing demand which the commercialized art market promotes, and its simplicity opens up the field even to nonart-

5. German Bazin, *Etudes carmelitaines,* Paris, Desclée de Brower, 1948, pp. 518–19.

ists. To produce art nowadays, says Möller, does not presuppose any intellectual prowess; the banality of form only equals the triviality of content. The viewer can instantly become a producer. A controlled apprenticeship, on the other hand, awakens spontaneity and creativity: every postulant can develop the necessary faculties to produce his own aesthetic object.

The quality of this kind of abstract painting is measured by the amount and the durability of the pleasure it gives. Triviality soon wears out, and the gap must be filled by new objects.

Spontaneity in a painter is an expression of passion, of excitement. The creative process frees tensions and instincts; it transfers the artist's psychic and physical state to his canvas. The struggle for survival, the discovery and liberation of self, the release, all culminate in a painting. What has been considered trivial in an abstract painting thus becomes an ideological message, replete with political implications.

One might touch here on the so-called "conceptual painting" which tends to be aggressive. A canvas depicting bread, for instance, will carry the message, "People are hungry," in a corner, usually politically inspired, of course. This sort of art, or pseudo-art, limited to propaganda—commercial or political— has no merit as art, which is not to say it is ineffective. That is why Möller says: "The liberation of art from its religious and technical ties [and thus ethical as well], has not produced freedom. For these ties could be called positive, since they do not attempt to manipulate man directly. Today they have been substituted by new ones, which we would call negative because, being amoral, they are closely connected to the direct manipulation of man, a manipulation or intent of persuasion which, by using aesthetic means, propagates political ideas.

"The emotion evoked by a Gothic panel in an altar piece, or, on a different level, by a simple carved wooden spoon, was positive; it only stimulated a feeling of inner harmony in tune with the total harmony of the world. This kind of 'sentiment' did not manipulate, it was a perfectly natural response. There was no trace at all of anything not relevant to the object itself or its function, whether transcendental or commonplace. The emotion was produced as much by the aesthetic qualities of the

12

object as by the ethical impulse which legitimized it [though all this of course came about spontaneously and unconsciously].

"Now, however, the absence of sublimated associations in art has given rise to the establishment of others, not sublimated, which distort its ethical laws. Who can deny that faith and beauty, added to the practicality of the 'useful' man, are in the last analysis very complex sublimations of primary human impulses? Man needs to create order, that is, he must submit to self-imposed rules and regulations, to establish relationships, in order to feel human. Only by reining himself in can he advance. All order is a selective system of limitations. Absolute liberty would be absolute chaos."[6]

To attempt to liberate oneself from the nature of things is to corrupt the spirit.

‖ We must not forget that mass-produced art, the product of a consumer society, has its counterpart—the creations of serious artists who are deeply conscious of the value of their labor. They are the rightful heirs of a glorious tradition.

We can rest assured that in the world of the plastic arts, there are masters in every country who follow the path which Cézanne, Gauguin and Rodin pursued, who have found the way to speak to the spirit and have recovered the means to deal with reality. The portraits of Van Gogh are proof that through the right perception of the material of life a great artist can apprehend the spiritual.

6. Heino R. Möller, *Art as Ideology*, Gustavo Gilli, ed., S. A. Barcelona, 1974.

CHAPTER TWO

Music

‖‖‖

We must begin by making certain distinctions between music of the past and the so-called music of today. For in our time, both noise and music exert unprecedented pressures and influences on human beings.

Factors range from the simple effect of music on the physical and mental health of a person and his ability to enjoy a concert, to the ideological use of music for a definite program of thought and action directed toward the destruction of man and society, especially in respect to youth. Although the following comments are interrelated in the deepest sense, the process of analytical investigation should clarify some of the problems.

The problem in music today consists in something far more complex than the simple dichotomy between classical and popular music and their respective influences. The traditional songs of each country, along with rock and other contemporary forms, certainly fit into a framework that used to be described as popular music, but they also raise questions outside of it.

In the classical or cultural music of this century a schism sprang up between tonal music—perfected in the eighteenth and nineteenth centuries by Bach, Mozart, Beethoven, and so on—and that which transgresses the bounds of tonality—the atonal, dissonant, cacophonic, what is now called the new music, composed by Schoenberg, Stravinsky, Varèse, and others.

Joan Peyser, in her book on the new music, explains atonal music as a twentieth-century phenomenon that is trying to do

15

away with tonality, "that special system of tonal organization which, after several centuries, came to be considered the natural law of music."[1]

This tonality of which Peyser speaks was rooted in the seventeenth century and consists of a scale of seven notes, one of which is the tonic or key note; the function of the other notes on the scale is determined by their relation to the tonic. This dynamic hierarchy dominated all the compositions of the Western hemisphere in the eighteenth and nineteenth centuries, and, of course, perdures in the twentieth.

In the past, various attempts were made to break through the tonal structure by composers such as Mozart (the Dissonant Quartet), Beethoven, Debussy, and Wagner, but it was not until 1908 that Arnold Schoenberg launched the atonal period in Vienna. In 1923 he inaugurated his new method of composing in a scale of twelve tones—"the technique of twelve tones," or dodecaphony. If the music of preceding centuries was linked to an ideal of dramatic expression, the followers of Schoenberg, especially Webern, transformed music into an abstract language devoid of any extramusical implications. Some claim that dodecaphony is the music best fitted to the scientific and technological space age, and, in this respect, unconsciously offers an appropriate vision of the world.

The revolution initiated by Schoenberg in 1923 was strongly resisted, not only by the public but by many composers who banded together as musical neoclassicists, among whom were such diverse figures as Stravinsky, Bartok, Milhaud, and many others. The neoclassicists rejected the twelve-tone system and continued to operate in the traditional forms of the nineteenth century, though Stravinsky did venture into explorations of the tonal field, balancing two tonic or key notes. (Stravinsky and Schoenberg were revered in their respective fields of neoclassicism and dodecaphony during the first half of the twentieth century.)

Edgar Varèse, the precursor of electronic music, is a special

1. Joan Peyser, *La nueva música: el sentido que encierra el sonido,* U.S.A., Delacorte Press, 1974.

case; he created a structure without melody, based solely on rhythm and sound. Although he remains unknown to the general public, his electronic modulations and atonal effects, produced on traditional instruments, have deeply influenced the new music. One of his ardent admirers, Pierre Boulez, stated in "Domaine Musicale"[2] that he venerated Varèse because he was a "marginal" and "solitary" figure who had the "rarity of a unique diamond."

Joan Peyser's enthusiastic acceptance of the new music leads her to make some statements which must be examined.

In the same book quoted above she reminds us that: "From the sixteenth through the nineteenth centuries artists focused their attention on man. Perspective in painting and tonality in music reflected the shift away from God's universe to the physical reality of the world. Tonality, with its built-in contrasts, was the perfect medium for the expression of human passions.

"But in recent years many artists have turned away from man, and begun to search, as in medieval days, for what lies behind man. The new and allusive total theater rejects the closed form with a beginning, a middle, and an end, in favor of an unstructured openness. Attracted by this concept, composers are groping toward something new, toward a symbol that cannot be paraphrased or fixed in a theoretical system. This new symbol must be approached directly, almost intuitively.

"We can only vaguely define the essence of the art of our times, but this much is certain: serialism, chance, and the total theater all share a common denominator—they reject rhetoric and expressionism. Thus they may be steps in a long journey toward the crystalization of a musical language that will serve as tonality did in its time.

"Max Planck, the great physicist, has described the contemporary condition of science in an essay entitled 'Where is science going?' He might as well have been writing of Schoenberg's *Pierrot Lunaire* or Stravinsky's *The Rite of Spring*.

2. "Domaine Musicale," mentioned in the prologue of Joan Peyser's book.

"We are in a position similar to that of a mountaineer, wandering over uncharted spaces, who never knows whether behind the peaks before him which he intends to scale there may not be another still higher peak . . . The value is not in the journey's end, but in the journey itself."

In these last words lies the key to the attraction of the new music. The journey of search is for the journey's sake, for the sake of change. And why? The attempt to escape human passions is only to fall into a total vacuum.

We shall return to this thought later; but for now let us point out that when Joan Peyser states, "many artists have turned away from man and begun to search, as in medieval days, for what lies behind man," she either confuses the various aspects of form or is totally ignorant of the profound meaning of medieval music.

We agree with Oscar Mandel in his article, "A Criticism of Cacophony," for the *South Atlantic Quarterly* that early in the century music joined the other arts in a far-reaching and exhaustive exploitation of ugliness (in the plastic arts) and evil (in literature).

"On the whole," Mandel writes, "that is the main artistic trend of the twentieth century. This double exploitation is what chiefly distinguishes it from previous art. Though the movement of art for art's sake was breaking away from so much of the past, and promising so much for the future, the respect for beauty remained almost intact in the 1890s. The initial liberation from bourgeois morals had to be followed by a second liberation: the cult of the beautiful had to be destroyed . . . and all the arts united to achieve this revolution."

This music does not aspire "to renew our spirit," as Bach wished to do, according to his annotation on the cover of the *Clavieruebung* (harpsichord studies, 1735), which is the least we can expect from music. The new music proposes to pay homage to the ugly, the discordant.

Fortunately, this new direction was unable to garner much of a following among the average cultured man, far less among the general public; consequently, it was restricted to hermetic

and esoteric groups, as though guided by an extraordinary spiritual arrogance.

The name George Crumb comes to mind—author and university professor—who has a fairly large following in younger circles and more public acceptance than many other serious composers of atonal music. Concerning this musician, Donald Henahan, music critic of the *New York Times,* writes: "George Crumb, composer of a new style, received a Pulitzer Prize for his work *Echoes of Time and the River.* In this work, musicians march across the stage in procession so that there is a constant and subtle change in the balance of the orchestral sounds."[3]

The composer has a sharp taste for the theatrical: on a darkened stage, for instance, musicians will appear with masks—according to Irwin Lowens, the historian and critic of music—or pianists hum as they play, and many of his pieces are based on numerology and magic. At one point in his work *Black Angels,* a grim episode in an amplified string quartet, the violinists and the violists play completely dissimilar themes while occasionally drawing their bows over partly filled tumblers of water. In other segments of the score, written at the height of the Vietnam War, shrill sounds of terror and violence pierce the ear.

Another work, *The Night of the Four Moons,* calls for an array of percussion instruments that include: ancient cymbals, Chinese praying stones, a high-pitched African piano, and wooden blocks used in the Japanese Kabuki theater.

Exotic instruments and their peculiar sonorities aside, Crumb's music is presented in scores of exquisite calligraphy; they are truly remarkable, almost pictorial, Henahan tells us. In several of his scores he inserts a phrase from Federico García Lorca's poetry: ". . . y los arcos rotos donde sufre el tiempo . . ." ("and the broken arches on which time suffers"), at which moment the broken arches are actually portrayed. The instructions to the interpreters are frankly poetic. This moved David Burge, one of his interpreters, to explain: "Each page

3. Donald Henahan, *New York Times Magazine,* 1967.

19

needs the most careful study, each new title demands reactions of a supramusical nature." Burge wrote his scores while "playing, thumping, singing, scraping strings, shouting, sighing, beating and whistling."[4] Whoever wishes to play Crumb must be a total musician.

Theodore W. Adorno, a brilliant music critic, has stated that a musical composition is determined to a great extent by historical forces to which each composer must find a solution, and thus his work can never be pure entertainment. "The problem of our times," Adorno writes, "was to establish the dodecaphonic music, introduced by Schoenberg and refined by Berg and Webern, so as to substitute it for tonality, which was already moribund. Looked at from this viewpoint, musical composition became a monastic discipline for true believers, and *music itself a tool for political and social change.*"[5] These last words express the ultimate aims of many composers, though rarely so openly stated.

In the so-called popular music, certain destructive aspects are more aggressive than in the more serious music. In Oscar Mandel's words: "The acid madness of rock music can be relied upon to satisfy orgiastic appetites: in short, there is an enormous outpouring of twentieth-century sounds that please the ears of the masses of today."

Later on in these pages, we shall try to establish the profound connection between serious and "popular" new music. For now let us consider the scientific studies that have been made of the effects of this music on listeners and performers alike.

A German publication, *Die Welt* (April 3, 1976), offers this documented statement: "Modern music, both rock and beat, as well as various types of serious music, have recently been found by reputable doctors to be a significant cause of tension.

4. David Burge; Irwing Lowens, *Washington Star;* and the critic and composer Nicolás Slonimsky, in articles written during the last decade.

5. Theodore Adorno, *Critica Cultural y Sociedad,* Barcelona, Ariel, 1970.

In the prestigious medical magazine *Selecta* this music is described as 'the rape of the audience' and *The Medical Tribune* suggests that modern orchestral music causes nervous tension, irritability, impotence and aggression."

Originally, the study was to have appeared in the *Karajan Foundation* series, with an introduction by Herbert von Karajan, but the project was abandoned, since the publication's purpose is precisely to support the new music.

The magazine *Selecta,* referred to above, describes in clinical details "the rape of the audience" by the new music. "The increase in the level of adrenaline, noradreline and hydrochloric acid provokes intestinal spasms and increases the physical production of coagulants; and the attendant circulatory risks of aggression and neurosis are detrimental to the balance of the nervous system."

A poll taken by Marie Louise Fuhrmeister of the performers of serious music in three great orchestras, who specialized in recording, revealed that those who played contemporary music were prone to physical and psychological problems. What is more, their professional occupation did not make use of their skills acquired through "long years of musical studies," since the new music with its arbitrary sounds and noises, magnified by electronic devices, nullified the need for technique.

These musicians spurned Boulez, Nilson, and Penderecky, and most particularly Karl-Heinz Stockhausen, for their "cascades of noises, discordant notes and terrifying signals of alarm." By comparison with these innovators, Hindemith, Bartok, Stravinsky, and Schoenberg sound almost classical. The majority of the musicians surveyed were convinced that their health was significantly affected by their recitals.

But beyond the physical repercussions, there are disturbing effects on the spirit when classical music is reproduced and distorted by a good stereophonic system. The phenomenon is taken up by an acute observer, Mario Lancelotti.

Lancelotti describes with great perception the emergence of a new bourgeoisie, a product of industrialism, the consumer society, which tends to evaluate everything in terms of economic status or the possession of material goods. This new

21

class, he says, is everywhere: it pervades the university and the government, runs factories, theaters, and publishing houses, dominates the arts and literature.

In a culture disfigured by advertising, the people of this new class move freely. Their ideal of culture—or its vulgarized pseudo-spiritual values—leans to decoration and specialization. Since they lack a sense of history and belittle tradition, they fail to understand that true culture is inalienable to society, that it is active and individual—and has social significance. They are admirers of the avant-garde because this gives them status. An "abstract" painting will gain approval or be rejected by this new bourgeoisie without reference to its traditional value or spiritual vigor.

"Industrial and technological progress, together with the emergence of this new class," Lancelotti writes,[6] "have contributed to the expansion of the stereophonic business. One can recognize a stereo buff by his elaborate collection of electronic paraphernalia and record collection; the availability and quality of musical reproductions enable him to enjoy the most famous performers, without leaving his home." Then Lancelotti adds the following characteristics:

1. The musical acceptance of volume and sound as inherent values inseparable from the listening process
2. A vague pedantry, based on the fact that one can purchase various versions of the same work
3. An immature or simulated knowledge of the score; and thus a superficial critical judgment

Stereophonics, according to Lancelotti, is the process of recording sound from one or various sources, located separately, in order to produce the effect of depth.

It is difficult to know the true aim of stereo. Because, though it creates volume and noise associated with a huge concert hall, as befits a mass public, it is not certain whether the industry is trying to imitate a "live" concert or simply cater to

6. Mario A. Lancelotti, *Digresión sobre la estereofonía,* Buenos Aires, *La Nación,* abril 25, 1976.

the bad taste of its clients and their need for self-glorification. A careful listening to a stereophonic concert is enough to persuade that the former objective is not achieved—the human ear proves far more "intelligent" than the machine.

Then, what *is* it that stereo offers? Lancelotti repeats: it offers a sound, a timbre, whose value is detached from the whole; it becomes, therefore, only a fragment, a part of the musical entity. That this fragment assumes a meaning and a value distinct from the total ensemble does not seem to bother the stereo buff. It is a total abuse of technology.

And this aberration, moreover, produces somewhat primitive sensations that have little to do with musical ideals.

Looked at closely, it is a diabolical invention. The stereo buff becomes a captive of the preciosity of the machine. But far more seriously, this new sound system has influenced musical interpretation. The stereo fan wants his transmission to be so pure that the acoustic and sensorial values obscure the meaning of the work as a whole; the stereo interferes with and separates us from the true discourse of the music.

The gradual desensitizing of the performers (under the demanding pressure of the recording studio) is seconded by the growing insensitivity of the listener. The public is content to receive a series of timbres, colors, sounds, volumes, without realizing that it is succumbing to a new form of barbarism—vulgar sensuality.

In contrast, a "live" concert stimulates the intelligence, because we retain our freedom and our responsibility. And we are rewarded for our effort with a completely conscious enjoyment of the concert.

This argument has convinced Lancelotti that the stereophonic system is basically a retrogressive stage of the auditory sense. Whether or not we share his opinion, we are forewarned that this "progress" could degenerate into sheer barbarism.

This barbarism emanates from an extremely sophisticated and powerful recordmaking industry which has little respect for the true nature of music. And the stereo fans, like the motorcycle or sport car fanatics, pollute our atmosphere with noise. There are obviously exceptions—the discerning listener

who can take advantage of the technical advantages while being aware of their limitations.

As for the new "popular" music, it has a vast range and an enormous public—it involves millions of records and numerous festivals throughout the world and directly influences our young . . . and not so young.

"Speaking of rock," says the pianist Gustavo Moretto, "we are dealing with the modern musical expression of a worldwide movement, with a complexity that stems from jazz. The movement was born in 1967 [much earlier many believe], when the Beatles introduced their revolutionary album *Sargent Pepper and the Lonely Hearts Club,* which seemed so daring then.

"Today the Beatles seem old-fashioned. The musical demands of today are tremendous. There are excellent musicians among teenagers who have done away with all the old rules."[7]

Concerning this rupture with the old forms, some thoughts are appropriate. It is common knowledge that the troubadours of medieval France used their love songs as a cover for their esoteric messages to spread the Cathar heresy. And today, this phenomenon is being repeated in psychodelic music, which, in what appears to be incoherent "hippie" language, incites the initiated to the use of drugs, sexual promiscuity, and social revolution. At times, the exhortations become frankly overt. Hoffman, the chief ideologist of one group, says: "We are openly challenging society and will destroy it through the communication media rather than with fire arms." And in one of his manifestos, Hoffman proclaims: "Each guerrilla fighter should become familiar with the particular field of culture he wishes to destroy."[8] Consequently, amidst flashing strobe lights, the music spreads its revolutionary message.

The Beatles, founders and backbone of this music, were initially influenced by Chuck Berry's work, with overtones of the blues and a kind of rhythm and melody that made teenagers yearn for maternal love. Its influence spread gradually and

7. Gustavo Moretto, *La Nación,* Oct. 3, 1976. Mr. Moretto is the pianist for the group, Alas.

8. *Pueblo,* Madrid, Nov. 7, 1975.

subtly. When the record producer George Martin and the talent scout Epstein launched the second stage of the Beatles, their music and lyrics contained not only a certain esoteric quality, but a sensuality bordering on frank sexuality. The 1964 record *A Hard Day's Night* was an important milestone. In 1966 they switched to their "idiomatic expression," and the iconoclastic Harrison replaced Lennon-McCartney as the charismatic figure.

Rubber Soul propelled the Beatles, the critic Silvano Hernández believes, into a more defiant revolutionary stance which became manifest in unusual orchestrations, emotional lyrics, and shorthand messages with sexual allusions (as in *Black Forest*) or in defense of drug use (*Yellow Submarine, Day Tripper,* and *Lucy in the Sky with Diamonds*).

This opened the way to attacks against religion (as in *Eleanor Rigby*) or against the political order (as in *Back in the USSR*). The music sends esoteric messages to the initiated public that transcend the lyrics, but are understood through rhythmic or musical symbols.

Consider what occurred at the famous rock festivals: in the New Port Festival on the Isle of Wight in England, in Burgos, Spain, or in New York State, where in the summer of 1969 over half a million young people gathered. A three-hour documentary of this festival was made by Michael Wadleigh and became known worldwide as *Woodstock,* and it demonstrated what happened both on stage and in the audience.

These festivals can last for several days. According to a keen observer at New Port, power over the young reaches the level of a conditioned reflex. On that occasion, the audience cheered the Viet Cong flag, proclaimed the "total liberation" of man and was provoked by certain rhythms to the point of almost killing a policeman. And all this through music.

The same observer noted other highlights of the concert: one hippie, with a heroic air about him, sang about his prison sentence for civil disobedience, followed by a song about a Vietnamese family burned by American napalm.

One spectator, according to the magazine *Open City,* spoke of his admiration for a particular singer: "Bob Dylan alone had

the power to draw us all here. He was our Shakespeare, our Lenin, our St. John of the Apocalypse. His incomparable songs are our declaration of independence"[9]—words that combine the literary, the political, and the theological. This subculture replaces melodious music ("fascistic," to them) with chaotic sounds and infernal noise (their "true music").

Rhythmic alterations in rock, moreover, as well as in other kinds of progressive music, have powerful mind-altering— even brainwashing—effects. Polyrhythmics, characteristic of progressive music, are capable—subliminally or otherwise— of intensifying the listeners' response. And therein lies the distinctive trait of this music: the endlessly repeated alternate rhythmic sequences—three-four and five-four.

Dr. Joseph Crow, professor of psychology at Pacific Western College, believes that "exposure to rock music can produce a hypnotic state. Young people listen to the same song hundreds of times . . . repetition is the basis of hypnosis."[10] The repetition increases the degree of suggestibility in the listener, which can lead to future unforeseeable reactions.

Charles Manson is a case in point. The heinous murder of Sharon Tate and her friends and the La Bianca family massacre can be linked to the influence of rock music which, combined with other destabilizing factors, went beyond simple hypnotism and produced total mental derangement.

As Ed Sanders amply documents in his book,[11] the blood-curdling events involving the Manson gang (the "family") are not isolated, nor a simple instance of terrorism, but an example of the powerful influence of a culture, a subculture, of the last few decades that has exacerbated the latent passions and insanity in each of us—the Hollywood "culture"—drugs, rock, occultism, youth gangs, demonism, what have you.

9. Silvano Hernández Hernández, "Rock and Revolution," *Réplica,* Mexico, 1972. Much of the source of the text is taken from this remarkable article.

10. David A. Noebel, *The Marxist Minstrels,* Tulsa, Oklahoma, American Christian College Press, 1974.

11. Ed Sanders, *The Manson Family,* Buenos Aires, Grijalbo, 1974.

In 1968, Charles Manson wrote a song called *Cease to Exist* for the Beach Boys. It became the theme song for the "family." Later, Wilson, one of the Beach Boys, changed it to *Cease to Resist,* on sexual surrender. It was retitled once more to *Never Learn Not to Love* and became one of the Beach Boys' greatest hits.

During that same time, Charles Manson became involved with several devil-worshipping sects and created one of his own called the Final Church. In a curious twist, Manson began to call himself Christ and Satan, or Christ and Devil.

Manson's own rock group, the *Milky Way,* found a great following among the select Human Institute to Achieve the Occult Touch, another cover for a secret demonic sect.

By the middle of January 1969, the *White Album* of the Beatles was released and, according to Ed Sanders, soon reached the 22 million sales record in the U.S. alone. This album, the first cultural message of the Beatles, became a symbol for the Manson "family." It was extremely revolutionary for its time, hypnotizing its listeners into a sort of ecstasy. He, the Christ, he, the Devil, was preparing the Second Coming: "Now it is the pigs' turn to get on the cross," it proclaimed.

The Beatles were the Four Angels that would unleash death, and Manson found support from Scripture to announce that there would be a fifth angel—the one from the bottomless pit, better known as "Charlie." Manson's favorite quote from the Bible was, "They repented not of their murders, nor their sorceries, nor of their fornications, nor of their thefts" (Rev. 9:21). He repeated it over and over again, preparing his followers for what was to come.

Manson began to listen to the Beatles' *Helter Skelter* and to hear voices, whispering to him, telling him to phone them in London. The song *Helter Skelter* from the double *White Album* is the Beatles' masterpiece, full of mysterious undertones, especially in the long final section where it twice fades out, only to return as a sort of triumphal march of the demented. (Manson associated the composition *Revolution 9* with the ninth chapter of the Book of Revelation.)

The album also contains the song *Piggies* and *Sexy Sadie,*

the last obviously producing spasms of delight in Susan At-kins, a member of the "family." "Sexy Sadie, she came along to turn everyone on," go the lyrics, and "you broke the rules, you laid it down for all to see." The demented actions, the knife in the throat, the forks in the stomach that destroyed the La Bianca couple, were obviously inspired by the song *Piggies.* "You can see them out to dinner with their piggy wives, clutch-ing forks and knives to eat their bacon." On a wall of the couple's home, "Death to the pigs" was smeared in La Bianca blood in a prominent place where it could be seen from the entrance. On the return trip after the crime, according to the trial testimony, Sadie and Clem sang excerpts from *Piggies*— the George Harrison song.

It would be tedious to cite each detail of the Sharon Tate and La Bianca murders, but it is important to point out these as-pects of "the new culture" which, like a chameleon, assume different shades without changing their destructive nature. Certain South American avant-garde literature demonstrates this and will be taken up in due course.

To return to progressive music: the ambiguous use of many words has become a sort of code of the acid-rock groups. Or, as Gary Allen says: "The rockers use an Aesopian language for teenagers, since the jargon is incomprehensible to most adults." This musical jargon is spread via disk jockeys, teenage gossip, and special channels of the press that circulate certain ideas, causes and messages.

Jerry Hopkins assures us that in the United States there are at least thirty national weeklies and a hundred underground dailies that are passed around among adolescents in any given city or university. Agencies of the fringe press such as the Un-derground Press Syndicate and the Liberation News Service were created to avoid being absorbed by the Establishment. These agencies not only distribute news but deal in records, books, and films connected with the musical world; they also offer religious indoctrination in Oriental creeds such as Hin-duism and Zen, which are symbolically associated with the drug culture. To list the songs advocating drugs would be end-less; suffice it to mention *The White Rabbit:*

One pill makes you larger and one pill makes you small.
And the ones mother gives you, don't do anything at all.
Go ask Alice when she's 10 feet tall, and if you go chasing rabbits,
And you know you're going to fall . . .
Tell them Hookah the smoking caterpillar has given you the call . . .
Feed your head, feed your head . . .

The pill that "makes you larger," a parody of Lewis Carroll's tale, is obviously an amphetamine, an "upper," and the one that "makes you small," is a depressant, or "downer."

The song suggests that to be yourself you must free yourself from your family, but to use drugs you need a "guru." The smoking caterpillar is clearly pot, and to "feed your head" is hippie talk for taking drugs.

The extolling of drugs leads imperceptibly to the boosting of total sexual freedom, so destructive for the young, not only because of the moral degradation, but because of the immediate consequences: illegitimate babies, abortions, the spread of veneral diseases. The statistics are staggering, and they explain why in most Communist countries not only is rock music strictly forbidden, its performers are often prosecuted.

In this respect, a story in *La Prensa* of Buenos Aires (Aug. 13, 1976), reported: "A Czechoslovakian court recently sentenced three rock'n roll musicians to terms ranging from eight months to two-and-a-half years for organizing a 'psychedelic concert.' The musicians were members of the group called The Plastic People of the Universe, whose idol is the American singer Bob Dylan. According to sources, the group organized the psychedelic concert during a wedding near the town of Pilsen, in the course of which obscene language was used." The verdict is not surprising when you consider the well-known axiom that a nation whose youth is degraded is a nation defeated. The same year saw a similar case in Russia.

As reported in *La Prensa,* a teenage magazine, *Cheetah,* summarized it by stating: "If the Establishment understood the true significance of modern music, they would outlaw it. But they only grasp the superficial content of the words without comprehending the true meaning."

29

It all combines in the categorical statement that socially de-
structive trends are being propagated by music; for a rev-
olution in customs and habits is bound to modify traditional
structures and—consciously, or subconsciously—bring about
changes in the socio-political and economic fields. This does
not mean that we should blindly defend the existing struc-
tures, many of which need radical changes, but that we must
realize that these revolutionaries do not offer any acceptable
solutions.

A random sampling of evidence is in order here. One of the
Beatles, Paul McCartney, was a card-carrying member of the
League of Young Communists, according to Silvano Hernández
in his famous article,[12] and as such was bound to tow the party
line. Socio-political change is *the* aim of these musical activ-
ists.

Sidney Finkelstein, the well-known American Communist,
writes in his book, *How Music Expresses Ideas,* that there
should be an eradication of differences between classical and
popular music. He recommends that popular music be used for
the propagation of Communist ideology, much as soap is sold
by sung commercials. Finkelstein suggests that classical mu-
sic give way to revolutionary hymns.

Peter Seeger, Lead Belly, Malvina Reynolds, and Woody
Guthrie have popularized songs about the struggles of the
classes and subversion. The New Left broke away from true
country music, and by combining folk elements with rock,
opened the mass market to Communist philosophy. Phil Ochs
and Bob Dylan are the chief exponents of this type of music.

The obliteration of distinctions between classical and popu-
lar music, as advocated by Sidney Finkelstein in his book, was
attempted seriously by Karl-Heinz Stockhausen who, by the
time he was forty-eight, was being venerated by the young
avant-garde. One of his most ambitious works was recorded by
Chrysalis, a prestigious British firm, which specializes in pro-
gressive rock. The record includes *Bird of Passage* and *Ceylon.*

12. Silvano Hernández Hernández, op. cit., 3rd. part: political rev-
olution.

Miguel Grinberg, a columnist in *La Opinión* of Buenos Aires (November 1976), has written an illuminating piece on Stockhausen and his musical conceptions. "From 1954," Grinberg writes, "Stockhausen has been a member of the Cologne School, a hot-bed of avant-gardism in electronic music, where he was able to realize his intuitions, experimenting with sound generators and wave synchronizers. Between 1954 and 1959, he was coeditor of the magazine *Die Reihe* [*The Rank*], where he expounded on his theories. For two decades he traveled extensively throughout the world, conducting orchestras, playing with small groups, teaching and lecturing.

"*Ceylon* was composed by Stockhausen in Ceylon during a motor trip. As the author said: 'Ceylon, in particular, contains something commonly found in rock music; that is, an interaction between precise rhythms based on rhythmic periods in close synchronization. In this work, these rhythms are much more intricate than is usually the case in rock music. Nevertheless, the listener, on hearing it, immediately starts to dance.'

"The invitation to this kind of dance is not typical of this composer's work, who in the *Bird of Passage* was obsessed with the need for youthful performers, and in his *Times* was experimental.

"Stockhausen is constantly inquiring into the essence of sound, and his mysticism prompts him to compose the kind of music that projects man toward 'the divine, the source of the Supreme Creation.' He is part of a process that tends to elevate the human consciousness which he terms 'the birth of a new era.' This new era must have begun around 1950, since this was when abstraction reached its acme not only in the arts but in the sciences.

"At that time, the new music entered a state of constant introspection in search of essences inalienable to the eternal, and with an asceticism that pervades Stockhausen's works. In this instance, the composer is not a manufacturer of consumer goods as happens with commercial popular music. Rather, he assumes the role of messenger, a human who catches strains from the 'music of the spheres' and transmits them like a

broadcasting station. And he requires of his listeners the same receptiveness that a Hindu guru demands of his disciple.

"Stockhausen is one of the few contemporary composers determined to make the three great discoveries: that of Nature herself, the nature of human beings, and the nature of sound. He invests his hopes of attaining ineffable happiness in his desire to understand the whole universe in all its richness. His music is the means, the vehicle for his voyage. It is not easy to keep up with him, for it entails forsaking innumerable prejudices. But the reward may be a 'conversion' which will transform life itself. This is Karl-Heinz Stockhausen's extraordinary proposition," Miguel Grinberg ends by saying.[13]

Earlier we commented on Joan Peyser's apology for national music and said that the journey of search is sought for its own sake, change for change's sake, leading to a total vacuum. Stockhausen himself confirms this: "I change my viewpoint constantly. As soon as I change it, I myself become transformed by what I have done. So what I do changes more, and I therefore demand more. I cannot say what the music and I are in this process. I alter music and it alters me. I can no longer be separated from it, much as one cannot separate music from the listener. The listener becomes the music, which in turn is influenced by the listener for he modifies it. What is music? I do not know."[14]

Considering his popular appeal and potential for preaching the "conversion" of life itself, Stockhausen's confession should be pondered together with his theories and music. This attractive "utopia" will undoubtedly appeal to most young people who, wrapped in the idealism and inexperience of adolescence, are seeking to elevate the human consciousness and to produce "the dawn of a new age"—a "new age" based on the deification of man and the consequent rupture from all in the past, a "new age" where all is licit and permissive.

From the pictorial and musical arms of art, these powerful

13. *La Opinión,* Buenos Aires, November 1976.
14. Jacques Doucelin, *Stockhausen y la búsqueda de lo sagrado,* interview in *Le Figaro,* Paris, Nov. 22, 1977.

currents converge and attempt to create a new man by destroy-
ing all that is great in our culture and civilization. The values
that made our culture reflect the sublime and the literary
trends of today will be discussed shortly. Joan Peyser's ponder-
ous statement—"Nevertheless, in recent years many artists
have turned away from man to search with medieval fervor for
what lies behind man"—must first be analyzed.

Peyser's comments conjoin with Stockhausen's belief that
the search for a transcendence is never wholly defined. Thus
Peyser uses a somewhat dubious symbolism, easily misinter-
preted, such as her reason for searching for what lies behind
man—the "medieval" character of the search—and "the
knowledge of ineffable happiness" which, through music, "will
transport man toward the divine."

It amounts to a monstrous travesty of medieval music, a
caricature of the significance of Gregorian chant. True, both
medieval and new music attempt to escape human passion, the
human condition, "converting" it to the mystical.

Now, having described the features of the "new music" and
thus the absurdity of its claims to any similarity with medie-
val music, what is the essence of the latter? In a strange way
Gregorian chant does fit Finkelstein's and Stockhausen's hopes
for music, for it embodies both serious and popular character-
istics.

Paradoxically, what most modern composers claim concern-
ing their music—a "vehicle for a journey of understanding of
the universe," which requires "abandoning numberless preju-
dices" thus pointing to "a conversion leading to a new life"—
all this is precisely how Gregorian chant affected H. A. Char-
lier. In his book on the chant, he attests that "it revealed to me
things that do not belong to earth, as no other music, no matter
how sublime, ever conveyed."[15]

The new music, for its part, tends to destroy tonality, to
abandon it to its death throes, and to replace it with antimusic.
How can man be so presumptuous? Through years of continu-
ous scientific and technological progress and an increased mas-

15. H. A. Charlier, *Gregorian Chant*, Buenos Aires, Arete, 1970.

tery of his environment man is being diverted from his metaphysical mission and diminished by an earthly positivism and a false estimation of his own capabilities.

"The excessive confidence in one's own power and unlimited progress," writes Marius Schneider, "is reflected psychologically in music by the endless chromaticism of the seventeenth and eighteenth-century music. The subjective encroaches on all human activity to the exhaustion of its very substance, and music is no exception to this intellectualizing trend."[16]

The painter George Mathieu, as pointed out earlier, did not attempt to launch a liberation from all previous forms. "An aesthetic art of the conscious will replace the aesthetic consciousness of art. This new art will create a new man."

The avant-garde composers and musicians in this century totally reject musical and spiritual tradition, and instead stress their own competence, rousing the primeval instincts and passions of man in the "search for that which lies behind man" that "will propel him toward the divine." To create the new man they want change for its own sake and resort to dabbling in magic and numerology.

Even jazz, as we shall see, assumes liturgical outlines in the attempt to change the image of man through art. Charlier asserts that jazz composers are very often talented men who, contrary to what is essential in a spiritual art form, have forsaken melodic invention for technical virtuosity; contemporary jazz, in consequence, drags men down to sensual barbarism.

In contrast to Gregorian chant, the new music encourages individualism, which can speak to society only through the senses. This music has nothing in it of genuine folk music, real country music—the "vidala," the "zamba," the "chacarara"—which are more religious at times in spirit than what passes today for sacred music. True folk music refreshes through a simple and sane happiness.

Gregorian chant has the quality of a bonding, a drawing together. Thought is confirmed and defined when expressed

16. Marius Schneider, *Il Significato della Musica*, Milan, Rusconi, 1971, p. 191.

through sound. Meditation through song helps to reject the individualism and leads to collective action. In the religious life, to sing is to respond and consent, Schneider says. The best psychological proof of this lies in the ancient aversion to polyphony in favor of the pervasive power of plain chant, where many voices join as one in the presence of God.

No soul exists, no matter how perverse, that cannot recognize truth when it is expressed in a language the soul can understand. Hence Gregorian chant—"a language of the soul addressed to the soul," as Charlier says.

The power of Gregorian chant is conveyed through sobriety, sincerity, courtesy, and the chastity of its forms. Its beauty is always fresh because it speaks as no other music can; it thus can move the souls of all. Its profound meaning is not easily understood—which applies equally to any of the arts—for it contemplates the loftiest mysteries, though its technique is easily grasped.

Schneider pinpoints the Gregorian within the vast field of cultured music, although, as noted, it also plays a part in what in the best sense is called "popular music," since it is composed for every man. As Schneider comments: "The basic thought behind the moderate and confident melodic lines of Gregorian chant is to create a means by which to reach God. The common ideal was: Adjutorium nostrum in nomine Domini qui fecit coelum et terram. By contrast, the impulse that inspired classical and romantic music revolved around conflict, a sometimes desperate struggle against the will of God. The music emanates an intensity, a rage, an agitation and restlessness more human than metaphysical, all of which is unknown in the Gregorian chant.

"While classical religious music seeks for extreme situations, Gregorian chant pursues a just balance; thus while the former may easily become dramatic or lyrical, the sober style of the latter approaches the spoken language. Gregorian chant contains a melodic wealth identical to any of the three stages of prayer [petition, thanksgiving, praise]. Classical music, on the other hand, is mainly motivated by the rhythm of supplication, not by that of gratitude or praise. This is also seen in

religious painting, which normally depicts hands expressing anguish or sorrow instead of a gentle joining in confident prayer.

"If we compare the moderate line of a Gregorian 'Kyrie' or 'Sanctus' with the same text in Bach's B minor Mass or Beethoven's *Misa Solemnis,* the difference of the inner attitude is immediately apparent. The Gregorian melody is a roadway for the community; the classic is a splendid highway but difficult and fraught with obstacles rising from the egocentricity, which is the source of its most inspired melodies. The difference can be realized by glancing at the triumphant theme of the liturgical Te Deum and at the magnificent but tortuous itinerary of the Dettinger Te Deum of Handel in the Latin version."[17]

Schneider's thoughts help clarify the difficult crossroads at which tonal music has arrived, in this "desperate struggle against the Will of God," which has gained strength in the subconscious of almost all the composers in our Western and Christian civilization. The magnitude is such that the stalwart defender of tonal classic music, Oscar Mandel, wrote in his article[18] on cacophony: "If we still believed in God, we could say this music exists to celebrate His glory. But in the absence of God, we can only declare that the music creates emotions, aesthetic pleasures."

Mandel did not grasp that the vast majority of new composers consider their music to be a valid interpretation of contemporary life, and even more, according to Theodore A. Adorno, an instrument of social and political change. Mandel continues his reflections: "If dissonance—rightly named—has for sixty years been unable to produce results, those who cultivate it should realize that the time has come to search along different lines. I am in favor of change and experiment, but that does not mean that invention is good for its own sake, or that every experiment is necessarily successful. It must be remembered that the faculty that senses the beautiful is less flexible than

17. Ibid., pp. 192–193.

18. Oscar Mandel, "Una crítica de la cacofonía," *The South Atlantic Quarterly,* 1973.

commonly believed; and that ugliness, like pepper, is an excellent seasoning but appalling as a main course . . .

"Perhaps the cacophonists of the twentieth century have been allowed the luxury of concocting musical structures in their laboratories because the Old Masters were there, ready to fill in the vacuum. They could therefore say, 'Beauty? People have been concerned with it for a long time: listen to Vivaldi. We look for something else.' But . . . there is nothing else," Mandel concludes.

These arguments obviously fall into the same pitfalls they criticize, and they end up more markedly egocentric than the old classical composers. Thus, the problem of creation in music is not only linked with the historical condition, as claimed by the famous critic Adorno, but with the definitive and decisive attitude of the soul of man before his God. In the final instance, either man is deified and rendered honor, or man must bow to God. The belief that all is permissible in secular music is in itself helping to pave the road that leads to the worshipping of man and to his ultimate destruction.

Herein, perhaps, lies the great dilemma of our civilization, not only as applied to music, but as part of the warp and woof of contemporary culture. The crisis is not only musical, but theological and cultural, and hence political.

There is reason to believe that the institution of the Gregorian, an art complete in itself, in religious life could transfer to the secular a sense of hierarchy that could revitalize the musical adventure that compelled Erick Satie to include the wealth of the chant in his modern works. Charlier opined in his book that "Debussy and Ravel both understood the substantial and incomparable novelty of the works of Satie."

In summary, then: in the musical world there are two conflicting attitudes. One, illustrated by the new music in its every variation, is neoclassical, atonal or dodecaphonic, and is carried to a vacuous transcendency which attempts to wrap itself in mysticism and asceticism and to lead to a "total conversion"; the other, while traveling along the old path, is of a new and lofty spirit, a fount of endless harmonies which can in some cases blossom into an authentic spiritual conversion.

We firmly believe that there are composers conscious of the great challenge who, consequently, are ready to rescue for music—even in its lightest expression—the marvelous harmonies of God, of man, and of the cosmos.

CHAPTER THREE
Literature

The correlation between art and spiritual conversion, already observed in pictorial art and music, obviously extends to literature—prose, drama and poetry—which exerts the same power. Certain figures in the field have exercised a decisive influence for good or for evil. Jean-Jacques Rousseau, in *The Social Contract* and *The Discourse on the Origin of Inequality Among Men,* was a felt influence in the political sphere. His aphorism, "man is born good, society corrupts him," implicitly negates Original Sin, to the relief of the bleeding hearts, and sways men, but does so without instructing them. But the conversion, in some cases a massive conversion, has been brought about through his romantic novels *Emile* and *New Heloise.* Both Bolívar and Miranda, for instance, leaders of the independence movement in South America, were deeply influenced by Rousseau.

The European novel also offers a completely different viewpoint. Dostoyevski, in *The Possessed,* a sublime work in the prophetic political sense, though not written for political reasons, fulfilled and continues to fulfill a very important mission in both the political and literary fields.

Dostoyevski knew that in his day the revolution had already begun, and was stirring in the subconscious of his contemporaries. In analyzing the phenomenon, he described the internal forces of subversion that strive to create a new godless social order. Tolstoy, on the other hand, was unaware of the start

39

of the revolution because, having been drawn into it, he was already one of its blind adherents.

Dostoyevski, says the writer Nicolas Berdiaev, dwells in the sublime sphere of the soul from where he contemplates what is happening and what will happen. Through his narrative art, symbolic as all great art is, Dostoyevski interiorizes man's actions woven in history, and in so doing points out his country's destiny and that of the human soul. His characters only rarely act normally; he describes human nature in ecstasy, alienated. He deals with the dark side of man, whose actions are not only touched by the subconscious, but which reflect the author's historically prophetic vision, a vision that describes landmarks in the struggle between Good and Evil, with the accent on the latter's negative aspects—crime, lust, seduction by the diabolic, and so on.

Man is not corrupted by today's universally accepted factors, that is, economic or political pressures. Rather, the destructive and corrupting agents operate from man's own nature, the terrible pride inherited with Original Sin, the satanic "nonserviam" felt in our own day and to the end of time.

Clearly, almost clairvoyantly, Dostoyevski demonstrates the point on the personal level in *Crime and Punishment* and on the political and social level in *The Possessed*. Consequently, in his most representative novels, he intertwines the spiritual currents that make up history: obedience to God and his laws, and rebellion against God—the attempt to supplant Him with a deified man and ultimately, consciously or unconsciously, with the Antichrist. With this profound vision, Dostoyevski was able to pierce the misty future.

The novel *The Possessed* is amazingly valid today because the guerrilla groups or cells to which Dostoyevski belonged in his youth have since proliferated, and will continue to do so, if the reasons for their existence are not eliminated.

The speeches of Shigalev, founder of the "revolutionary-anarchist-nihilist" lodge, preach a utopia of extraordinary yet credible dimensions. In a meeting of one group a lame professor expands on Shigalev's theory. "I know his [Shigalev's] book and the final solution it suggests . . . the division of mankind

into two unequal parts. One-tenth enjoys absolute liberty and unbounded power over the other nine-tenths. The others have to give up their individuality and become like a herd, and, through a boundless submission, attain a primeval innocence, as in the garden of Eden, though they will have to work. The measures proposed by the author for depriving nine-tenths of mankind of their freedom and transforming them into a herd, through the education of whole generations . . . are remarkable, founded on the facts of nature and highly logical. One may not agree with some of the deductions, but it would be difficult to doubt the intelligence and knowledge of the author."[1]

Later on in the novel, Shigalev himself proclaims: "What I propose is not contemptible; it's paradise, an earthly paradise, and there can be no other on earth."[2]

It all paves the way for the appearance of the Antichrist and demonstrates a Dostoyevski so prophetic as to make him one of the greatest Christian writers of the West. His vision reaches its peak when through Ivan, a character in *The Brothers Karamazov,* he proposes the creation of a new church from within the old, which would supplant the God-man figure of Christ with the human figure of the Grand Inquisitor. While not denying the divinity of Christ, Ivan does deny the Creation and Divine Providence.

Here Dostoyevski's prophetic vision reaches such heights that only a careful and repeated reading of his workings and an intelligent observation of our surrounding reality can bring out the fullness of his work.

Dostoyevski forces us to think on three levels, the theological, the cultural, and the political, all basically interrelated. To meet this challenge one must grasp the scope of his ideas. Dostoyevski's genius is that he discovered and described what one might call the greatest disease of the twentieth century— the undermining of the natural and supernatural orders in the

1. Fiodor M. Dostoyevski, *Demonios,* Aguilar, Madrid, 1961, Obras Completas Tomo II, p. 1336.
2. Fiodor M. Dostoyevski, op. cit., p. 1337.

name of social justice. We must of course strive for social justice, constantly and tirelessly, but not to the detriment of the natural and supernatural orders.

The author himself reveals the source of his inspiration: "I am called a psychologist," he said, "but this is false. What I describe are the depths of the human soul." And he delved so deeply into the hidden strata of the human soul that he was able to predict the future direction of his country, as well as that of the entire West.

Solzhenitzyn, Dostoyevski's finest and profoundest heir, now exiled in the West, bears witness from a universal perspective in his *Gulag Archipelago* to an entire period of his country's history. In his work he professes something akin to Dostoyevski's vision, worthy of meditation and relevant to what is happening around us.

"To do evil a man must first believe that the evil is good, or that it is logical and has meaning. Fortunately, it is in the nature of man to seek justification for his actions.

"Macbeth's self-justifications were feeble, and his conscience devoured him. Iago was another lamb. The imagination and spiritual strength of Shakespeare's evildoers stopped short at a dozen corpses. Because they had no ideology.

"Ideology—therein lies the long-sought justification for evil that gives the evildoer the necessary steadfastness and determination. It is the social theory that helps to vindicate his acts in his eyes and those of others; thus, rather than reproaches and curses, he will receive praise and honors . . .

"Thanks to ideology, the twentieth century has experienced wickedness perpetrated against millions of people. This cannot be denied, nor ignored, nor suppressed. How, then, do we dare insist that evildoers do not exist? Without them there would have been no *Archipelago*.

"That is the line that the Shakespearean evildoer could not cross. But the evildoer with ideology does cross it.

"When we keep silent about evil, burying it so deep within us that no sign appears on the surface, we are nourishing it, and it will rise up a thousandfold in the future. When we neither punish nor reproach evildoers, we are ripping away the

foundations of justice from beneath new generations. That is why the young are 'indifferent,' not because they receive a 'weak education.' Young people are becoming convinced that wicked deeds are never punished on earth, that they help bring prosperity. How uncomfortable, how horrible, to live in such a country!"[3]

Solzhenitzyn's vision could not be wiser nor more penetrating. It clearly reflects what is happening in Russia, and, for that matter, in the West. We are witnessing a change in our society, a violent and irresponsible struggle that seeks surreptitiously to transform the thinking process itself. And in this, literature plays an important role.

But literature can also·uncover the hidden evil and unmask the people who, under the guise of doing good, are actually spreading evil. When literature—fiction at its artistic best—presents a true picture of reality, it fulfills its great mission. This is precisely the burdensome, lifelong task undertaken by Dostoyevski, Solzhenitzyn, and numerous other writers whose work had and will always have an indirect but undisputed socio-political influence.

A few observations concerning some of the better-known and popular writers of the Latin American avant-garde in literature might prove interesting.

In 1983, García Márquez was awarded the Nobel Prize for Literature, which afforded him universal influence. In his acceptance speech, he said provocatively: "Why is it that the originality we are permitted without reservation in literature is denied us with such mistrust when we apply it to social change?"

Nevertheless, two books published by García Márquez are significant for focusing on a negative *spiritual conversion* linked with a radical social change.

In *One Hundred Years of Solitude,* one of his major works, García Márquez transports us into a magic world, where some of the characters still believe that their doomed community

3. Salvador de Madariaga, *Imperfección frente a perfidia: El Archipiélago Gulag, La Nación,* Buenos Aires, 26 de enero de 1975.

can be saved; but as for the others, "their souls are crystalized by a nostalgia for lost dreams because the voracity for forgetfulness is mercilessly devouring their memories."

In this atmosphere of deep and magical reality, irreverent bells are ringing, but their tolling does not drown out the enchantment: "If they believed in the Holy Scriptures, why not in me?" With delicate wit he ridicules the clerical class and the See of Rome, implicitly destroying everything they stand for.

Márquez' intention in *One Hundred Years of Solitude* is not merely to taunt the unbeliever. It is the deep rebellion of one who, although capable of seeing the light, voluntarily blinds himself in order that his private vision might prevail. The intention is manifestly to "create a new order" by a conscious parodying of the Bible. There is talk of a foundation (Macondo), of guilt, a march toward the unknown, a deluge—obscene and blasphemous insinuations all of which serve to degrade the "literary quality" so cherished by García Márquez.

For example, in his *One Hundred Years,* "Remedios, the Beauty . . . was not of this world," because "from the time she was in her mother's womb, she was safe from contagion." Her "innocence" is shown in her behavior: "The startling thing about her simple instinct was that the more she shed fashion in search of comfort and the more she shunned conventions to allow for spontaneity, the more disturbing her incredible beauty became."

The "conventions" are nothing more than a basic sense of decency, and his long descriptions of them are, or ought to be, unprintable. This "pure being" arouses in others the basest of instincts. But the satire does not end here: Remedios the Beauty is "taken up to Heaven, body and soul." The allusion could not be clearer nor more diabolic.

In the same vein he refers to the carnival as a "Catholic tradition" and simplistically converts the concept of sin into a capricious play of words. But the most overt attack on the Christian faith and the Catholic Church is reflected in the person of Fernanda del Carpio, an absurd character embodying "Christian" values, which are thoroughly caricatured. "Fernanda did

44

not relinquish her drive to impose the customs of her ances-
tors . . . The custom was planted, like reciting the rosary before
dinner, and it so drew the attention of the neighbors that soon
the rumor circulated that the Buendías did not sit down to din-
ner like other mortals but had changed the act of eating into a
kind of high Mass. Even Ursula's superstitions, which arose
from the inspiration of the moment rather than from tradition,
came into conflict with those of Fernanda, who had inherited
them from her parents and kept them well defined and cata-
logued for every occasion."

In the "new world" of "Macondo" there is no Redemption be-
cause Márquez, true to the materialistic and cyclical view of
history, denies it: "I know all this by heart," Ursula shouted.
"It's as if time had turned around and we were back at the
beginning."

In that "circle" so completely opposed to the Christian con-
cept of time, there is no place for hope. Márquez' "world" has
no meaning, no finality, and thus he destroys it: "Macondo was
already a fearful whirlwind of dust and rubble being spun by
the wrath of the biblical hurricane."

The only possible happiness for man seems to be the un-
bridled abandonment to "total liberation" of Amaranta Ursula
and Aureliano Babilonia. In this context the praise of vice
seems logical, and is defined as the "maturity of judgment."[4]

Nothing is left untouched. Not even the literary field: "It had
never occurred to him before that literature was the best toy
ever invented to make fun of people." Thus, in a world without
hope or values "the only thing that works is violence."

He mingles the powers of the laws of nature and of the spirit,
and disingenuously muddles up Good and Evil, thus befud-
dling our powers of reason. And he can do this because he is
able to conquer our admiration through his vibrant poetry and
the pathos of his humor.

In *The Autumn of the Patriarch* the author's daring reaches

4. Gabriel García Márquez, *Cien Años de Soledad,* Buenos Aires,
Ed. Sudamericana, p. 235.

new limits and greater subtlety. The novel has the power of a negative conversion in both the political and the religious spheres. He leaves not a shred of dignity to the military career, pinning on it every conceivable kind of degradation. Mercilessly, he destroys whatever nobility the military career might embody.

If the reader is a lukewarm believer (of the purely rational or sentimental sort) and willingly plays Márquez' games, he will risk losing his remaining convictions. What, then, is Márquez' game?

In *One Hundred Years of Solitude,* he ridicules the clergy and hierarchy through their simplistic and puerile moralizings. And he does so convincingly by mixing truth and falsehood. In *The Autumn of the Patriarch,* on the other hand, the ridicule has become cruel, satanic, and it degrades the entire supernatural world. Márquez does this gracefully and with humor, and if the reader is not immediately alerted, he loses the game from the start. Our spirit is surreptitiously captured, for the enemy is disguised in expressions of brilliant artistry, and we are seduced to the point of reverence. If our aesthetic admiration is not accompanied by prudent reflection, if we are not alert to the danger to our most sacred beliefs, then we are on the path of a negative conversion. The vestiges of our religion will be undermined by his aesthetics and his skepticism, and our political eyes will be dimmed.

The novel has no specific paragraphs that could be readily cited as proof of this contention; rather, it permeates the entire fabric of the book. Suffice it to mention the civil canonization of Bendición Alvarado, mother of the patriarch, whom he personally declares a secular saint, a decision based on the findings of Bishop Demetrio Aldous, special envoy of the Vatican, who has been delegated to gather the necessary proof. Concerning the clerical worthy, the author writes: "Demetrio Aldous, auditor of the Sacred Congregation of Rites, Postulator and Promoter of the Faith, by the order of the immense Constitution and for the splendor of Justice for all men on this earth and for the greater glory of God in Heaven, I declare and

46

affirm that this is the truth, the whole truth, and nothing but the truth, Excellency, and I present this record to you."

The process of beatification, given Bendición Alvarado's licentious life, is an obvious farce from the start. The patriarch decrees the civil sanctity of his mother, and simultaneously declares war on the Vatican. By a succession of such incidents Márquez subtly dismembers the supernatural order; more than once, events occur "under the golden dome of the deceitful world of that difficult God, the one and triune."

José María Alfaro y Polanco, literary critic for the newspaper *ABC* of Madrid (November 7, 1975), dedicated a whole page to this work, of which the relevant passage follows:

"One could say that one of the first fruits of this dense prose, with its superbly convoluted use of nostalgic poetry, is its involved rhythm, where even the use—and reiteration—of an explosive and offensive eschatology has the effect of an intricate mosaic.

"The Autumn of the Patriarch is a tremendous and polished chronicle of the decadence of a typical South American dictator. An indolent and pitiless 'deck-chair morality' is all pervasive."

Can one so easily dismiss the profound and irreverent subversion of the natural and supernatural order—the "deck-chair morality"—no matter how cleverly done? We believe that García Márquez, who expended his artistic energies between 1968 and 1975 in *The Autumn of the Patriarch,* may have contributed to and even increased the negative conversion of many of his readers, but without their least awareness.

Much more could be said about García Márquez; a technical analysis of his style would consume a book in itself. But since there are thousands of like works that exert an incredible political influence, the symbolic overview given here must suffice. The current Latin American literature—so much in vogue here and abroad—is overflowing with political purpose, which if mostly superficial, is nevertheless convincingly presented, particularly given its powerful connections.

This does not quite pertain to García Márquez, whose inten-

tions are not so superficial as they appear. For Pablo Picasso's declarations concerning the art world are complemented by García Márquez' confession:

"So that there be no misunderstanding, let us start at the end. I believe that sooner or later the world will become socialist, and for my part, the sooner the better. But I am also convinced that one of the things that can delay it is bad literature. Now, my personal reservations concerning the so-called social novel, the high point of the politically involved novel, are based on the fragmented, exclusive character of the novel which condemns the reader to a partial vision of the world and of life. The failure of this type of novel in our countries gives rise to the thought that the Latin American reader, although he may not say so, realizes its limitations. This explains the great paradox: the writers who, in good faith, wished to express the terrible political and social dramas of our majorities, and nothing but, have become the least read in the world.

"Sartre said that, if one wishes to remind the French of the horrors of the occupation, one need only write about a military band playing German music in a public park. This seems to me to apply to Latin American readers. To my mind they do not need to keep hearing about their own drama and oppression and injustices; they are surfeited with it daily and suffer from it with their own blood. What they look for in a novel is something new. I think that we contribute to a better life in Latin America not by writing well-intentioned novels that nobody reads, but by writing good novels. In a word, I believe that the revolutionary duty of a writer is to write well. That is his obligation."[5]

The course envisioned by García Márquez is profound and far-reaching. He wanted to depict a total world in his novels, from its inception to its fruition, and he succeeded. Something essential is nevertheless missing: the uncompromising presence of a transcendental order, real and alive, without caricature or sham. García Márquez can not quite supplant it, nei-

5. Miguel Fernández Brasso, *The Solitude of Gabriel García Márquez,* Barcelona, Planeta Pub., 1972, p. 94.

ther with his marvelous and well-wrought literary style, nor with his sarcasm and the genial humor of his sharp but dark spirit.

This daring kind of "infra-literature" (that permeates the popular magazines that find their way into most households) and their ideas are constantly absorbed by a vast audience. The term "infra-literature" signifies that the writing does not live up to García Márquez' self-imposed canons of perfection, but it is nevertheless most effective. In fact, the avant-garde literary movement in Latin America reaches even deeper dimensions than those described above. It is not a case of a solitary writer taking arbitrary pot shots at the Establishment.

The phenomenon of this avant-garde movement is explored in a slightly superficial but extremely eloquent manner by José Blanco Amor,[6] and convincingly demonstrates the kind of political entity that sponsors the Latin American literary venture. In this article, the underlying political slant and the interrelations among the various branches of culture are clearly spelled out.

That these various writings converge and proceed from a political center had not been fully understood until the publication of this article, with the subtitle "Literary Terrorism in Latin America."

The writers who are mainly concerned are: Carlos Fuentes, Gabriel García Márquez, Julio Cortázar, and Mario Vargas Llosa. A few others—like Juan Carlos Onetti, Augusto Roa Bastos, João Guimarães Rosa, Alejo Carpentier, and so on— are not the main part of the "boom" but are more like a Greek chorus accompanying it.

Given that these authors have recently been the most widely read in Spanish-speaking countries and loudly heralded by the literary critics in Latin America, we must disagree with Blanco Amor on one point, namely, when he states that "now, after thirteen years, [the critics] have forgotten the subject."

One has only to note to what extent these writers are re-

6. José Blanco Amor, "The End of the Boom," *La Nación*, Buenos Aires, March 23, 1976.

quired reading in the universities and high schools in Latin America and elsewhere to realize their continuing influence.

"The professors outline the work of these famous writers," the Venezuelan newspaper writer and author Juan Liscano says, "and the students elaborate on the thesis. When I use the word 'famous,' I use it to describe the fast-selling authors of the moment. American professors are perhaps the main promoters of what could be called the 'boom' tendency.

"When one picks up an American magazine or a literary publication, it is amazing how often the same four or five Latin American authors crop up, and how lacking they are in any broad vision of the movement, which together create an unbalanced view of the whole."[7]

Moreover, the methods employed for analyzing these literary works, such as structuralism, consciously or subconsciously play into the hands of these theorists.

"Who united them? Why did they unite?" Blanco Amor asks. "The 'boom' exploded like a Latin American atom bomb. Everything was admirably orchestrated. The weeklies in Argentina were the first to launch the adulatory campaign which was echoed in all the other Latin American centers."

Blanco Amor goes on to quote from an interview with the writer Carlos Coccioli in 1967. He wrote: "'A literary Mafia exists in Latin America,' he told me; 'certain writers become so inflated that they threaten to burst like balloons. It happened in Mexico with Carlos Fuentes' publication of *The Sacred Zone*. It is nothing novel, though it tried hard to be sensational.' Coccioli went on to maintain that the literary Mafia is the result of a sort of political-commercial coalition between a group of writers and certain Argentinian and Spanish publishing houses, with Havana's stamp of approval.

"Coccioli, in reviewing some of the group's political leanings, states: 'One can be sure that any given page written by these authors clearly identifies the political preferences of all of them: pompous invectives against imperialism, capitalism, the Pentagon, the Vietnam War, the military gorillas, and praise

7. Juan Liscano, *La Nación*, Buenos Aires, March 21, 1976.

for Castroism. What contribution has this group made toward the technical improvement of the South American novel?'"

Blanco Amor, in his answer, quotes Professor Pedro González,[8] an author who, from a selection of certain passages from Cortázar's writings, demonstrates to what extent the latter is indebted to Joyce. González concludes: "These pieces show the linguistic hybridism and lexical coarseness that set the tone and characterize *Rayuela,* the novel by Cortázar." The criticism applies equally well to Vargas Llosa and Carlos Fuentes.

Blanco Amor continues: "Latin America was just an excuse; the Cuban revolution had recently focused the world's attention on this continent. A few selected works were presented as the final synthesis of the meeting between the Latin American man and his social, political, and human environment. The public rushed to the bookstores to find an answer to their anguish, their loneliness, their isolation in today's world. What they found was a trap, a 'new' literature that was 'old' by world standards."

What emerges from Blanco Amor's comments is that the aesthetic and political phenomenon is already quite outdated. But it is by no means finished. Instead it has spread to Europe, acquiring a profundity far greater than anything the authors intended.

On August 28, 1976, most of the Western press carried the following UPI news item: "London: On Monday, one of the most famous Latin American novelists, the Peruvian Mario Vargas Llosa, was elected in absentia to a three-year term as president of the Pen Club International, an association of poets, essayists and novelists from approximately seventy countries. In a message sent to the gathering, Vargas Llosa, forty years old, promised to continue the work of the Pen, 'to keep the doors open and to combat injustice in the East and in the West, in the developea and underdeveloped countries.'"

On September 18 of the same year, *La Prensa* of Buenos Aires published the following UPI item: "Frankfort: The 28th

8. Miguel Pedro González, *The Latin American Novel in an International Context,* México, Tezontle, 1967.

Book Fair of Frankfort introduced yesterday to the public a plethora of artistic creativity which, according to the president of the Pen Club International, the Peruvian novelist Mario Vargas Llosa, is deeply rooted in the little-known literature of Latin America. He also declared that this display will help to establish a dialogue between Latin America and Europe, the center of world literature . . .

"'Neither dictatorships, nor injustice, nor even underdevelopment could prevent the literary activity and formation of a creative spirit in Latin America; works that show our complexity, our variety, our poverty, and our dreams will through their originality enrich the culture of our times,' concluded the Peruvian writer."

Concerning the originality of the new Latin American literature, as claimed by Vargas Llosa, we repeat that the authors not only imitate European methods and techniques (novelists like Proust and Hesse) and English-speaking writers from both sides of the Atlantic (Joyce, Faulkner) but while residing in Europe—Cortázar in Paris, García Márquez in Barcelona, Vargas Llosa in London and Barcelona—the great majority claim to be breaking away from the hated colonial yoke.

Is Vargas Llosa truly a totally unbiased head of Pen Club International? Is he free of imperialistic ties, cultural or political?

The international promotion campaign mentioned above appears to refute Blanco Amor—the propaganda phenomenon has not eased up. The political and cultural importance afforded the "new literature" at the top levels of the literary world forces us to delve deeply into the Latin American phenomenon. We must explore the springs that prompt these writers to consider themselves the founders of a "new revolutionary society" destined "to destroy forever the cultural, economic, and political system of an outworn and rigid society."

Our society does undeniably suffer from many ills and failings which should be recognized and corrected with courage and intelligence. But the proposed solutions of the new literary circle are no more acceptable than the political utterances of the authors, given the natural order and our Christian tradi-

tion. Nor should this tradition be confused with the distorted version espoused by these writers.

To reach to the core of this literary phenomenon, certain highlights of the work should be probed—those dealing with God, Latin American society, man, myth, Christianity, language, utopias . . . These elements are overtly or covertly intertwined in the works of these writers, and the thinking, the sensations and experiences of their lives are transformed in the creative process and become the reality of the novel. Thus the critic Zunilda Gertel could say of Carlos Fuentes:

"His [Carlos Fuentes'] novels are plainly leftist in their socio-political attitude; but subtly written."[9]

The novelists' public utterances printed in books and newspapers, which give testimony to their ideas and aspirations, cannot be ignored, nor can the criticism that allows thousands of students and readers to penetrate and participate more fully in these fictional works.

Some critical essayists, for instance, point out certain traits held in common by the new novel and the music of Stockhausen. But first a brief mention of Vargas Llosa, whose own words clarify certain of his interior attitudes, thus allowing the reader to penetrate the labyrinth of his fiction.

"If violence tends to congeal, one must try to thaw it, and this is a job for language, which is converted into a kind of vertiginous rhythm involving the reader to such a degree in the subject matter that finally he can no longer judge, he will accept anything and feel himself an integral part of it. I think that the obligation of the author who wants to be a realist is this: To transmit these experiences using all the necessary processes so that reality does not freeze hard."

And in another passage, referring to a section of *The City and The Dogs:* "Language here fulfills a very important function. It evokes reality by assimilating it into its own rhythm. It becomes lyrical. It radiates, it trumpets violence. It is hypnotic poetry, a solemn music that engulfs the reader in its res-

9. Zunilda Gertel, *The Contemporary Latin American Novel,* Buenos Aires, Columbia, 1970, p. 115.

onances, sweeping him up into the stream which at times is filled with obscenities."[10]

These few words spell out an intention and a goal. There are many Spanish-speaking critics who have dealt seriously and not without sympathy with Vargas Llosas' works.

And now on to Julio Cortázar, but not without first mentioning certain of his critics and commentators, since they constitute a part of the cultural enterprise that functions so efficiently: Graciela Maturo, an important figure who heads the Center for Latin American Studies, which promotes the values that are extolled in the new Latin American culture; Lida Aronne Amestoy, author of *Cortázar: La Novela Mandala;* Mercedes Rein, author of *Julio Cortázar, El Escritor y Sus Máscaras;* and Luis Harss, author of *J. Cortázar o La Cachetada Metafísica.*

It is well to concentrate on *Rayuela,* because it is Cortázar's most representative novel and it offers the most insights into his work.

What is Cortázar trying to achieve with his novel?

The unwary reader can easily become disoriented in this maze of surprises, from the repugnant ones (quite frequent), to those that "grab" him. In any case, he will discover a new kind of literature, similar to Stockhausen's music in that everything harmonious, everything considered noble—beauty, piety, tradition—is trampled upon. We are urged to take that great step, to leap to the other side; and to do so we have to deny our convictions no matter how valuable or perfect we may consider them. We are urged to purge ourselves of the evils that ail our society, and to this end, we must plunge into moral depravity and destroy our "prejudices," that is, our higher principles. "Piety is Oliveira Cortázar's great fear and hate, because it is the common denominator in the Great Tradition."[11]

Recall how Grinberg, referring to Stockhausen's new music,

10. Luis Harss, *Los Nuestros,* Buenos Aires, Sudamericana, 1969, pp. 437–439.

11. Lida Aronne Amestoy, *Cortázar: La Novela Mandala,* Buenos Aires, F. García Cambeiro, 1972, p. 74.

explained that it was not easy to follow him, for it demanded the abandonment of our prejudices, but that the reward would be tantamount to a new life.

Cortázar, while breaking the barriers of literature and possessing a strange sort of metaphysics, prefigures the Odyssey of the twentieth-century man. *Rayuela*, together with *Ulysses*, is the cultural backbone of a neo-Marxist enterprise—though not labeled as such—which will illuminate the new era. Or, as Cortázar says in *Rayuela*: "to use the novel as one uses the revolver, to defend the peace, changing its sign."

Cortázar is an adherent of the occultist philosophy of Ouspensky. According to this thinker, art is capable of enlarging the powers of perception, of reclaiming the deeper reaches of the mind, and of grasping all of reality, the visible and the invisible.

In the interview with the critic Luis Harss, Cortázar commented: "The game for the game's sake hardly exists in our literature. I wrote these texts [*Cronopios* and parts of *Rayuela*] as pure games."[12]

André Breton and the surrealists, in line with Freud's theories, define freedom as the release from all sexual and political repression. Likewise, they promote a return to childhood affection since children love everything. Games, being childish inventions, are good psychotherapy for children and adults alike.

"Herbert Marcuse," Jack J. Spector writes, "views Freud from a Marxist angle and bases his hopes for a utopian society on the transformation of work into pleasure. He believes that 'time' can be defeated by games ... Marcuse maintains that games can not only cure a man's neuroses, they can liberate him, transform him."[13]

With some of the keys to Cortázar's thinking in hand, the reader can proceed to embark on the adventure of reading *Rayuela;* he can understand the author's goals: to play games with

12. Luis Harss, op. cit., p. 293.

13. Jack J. Spector, *The Aesthetic Ideas of Freud*, Buenos Aires, Timerman, 1976, p. 280.

the reader. The reader is also warned that it is a very danger-
ous game. The aim is to win. The cost does not matter, winning
does. No matter what: to win. To win what? "Faith and new
hope . . . which constitute an authentic gospel for the last gen-
eration," since Cortázar, "the apostle and founder of authentic-
ity, . . . will create a new conscience," making the reader an
accomplice, forcing him to "act."[14]

These are some of the conclusions drawn by Lida Aronne
Amestoy in her study of Cortázar. She opens her chapter with
the following epigraph:

> He acts like a guerrilla fighter
> He blows up everything he can, the rest
> follows its way.
> Do not think that he is not a man of letters.
>
> *Rayuela,* p. 509

Cortázar's total and destructive rebelliousness compels him
to say: "I shall die without having lost hope that one morning
the sun will rise in the West. Its perseverance and obedience
exasperate me, something which would not bother a classical
writer."[15]

One of his recent books, *Journey Around a Day in Eighty
Worlds,* holds a surprise for the aesthetes, for it presents a Cor-
tázar lyrically involved with the Cuban revolution, according
to Luis Harss.[16] "To the Left and on the Red," to quote him. But
why should this surprise us since Cortázar considers himself a
chief exponent of the total revolution?

After this small incursion into Cortázar's spiritual back-
ground, those brief words of Gabriel Marcel will summarize a
characteristic common to all the avant-garde Latin American
writers: ". . . man will be forced to view himself as some kind

14. Lida Aronne Amestoy, op.cit., pp. 98–99.
15. Luis Harss, op. cit., p. 297.
16. Ibid., p. 464.

of cosmic debris . . . at the same time and for the same reasons he will both exalt and mercilessly denigrate himself."[17]

Cortázar dares to snatch man from God's hands, presuming to change and rearrange him better than the Creator himself. This is not a novel concept. The greatest Christian writer of the nineteenth century, Dostoyevski, clearly foresaw it:

"If a man is not essentially a coward, he should do away with all the fears and all the prejudices that keep him back," says Raskolnikoff in *Crime and Punishment*. "It is not my intellect that helps me, but the devil."

When Raskolnikoff confesses his crime to Sonia—his obsession concerning the superman—"the young woman felt that his fierce creed had become his faith and his law." If Raskolnikoff feels overwhelmed and pitiless, it is not because he has lost the sense of being made in the image and likeness of God, but because he has been defeated in his attempt to overcome the obstacles that prevent him from becoming superman. And is this characteristic not exactly what sets the tone of the new novel?

‖ Latin American writers who promote the new humanism in America are in a very curious position. The intellectual elite tries to reinstate the continent in a mythical primordial period. They use artistic methods very similar to those employed in the Theater of the Absurd. They do not realize that ultimately they are the victims of the spiritual movements they claim to reject, but which instead become revitalized.

The languages of art were barraged by cubism, dadaism, surrealism, atonal music, Joyce, Genet, Brecht, and Ionesco. Their followers only continue the destruction though they fancy themselves to be creators of a new cosmogony. These elites, through the eccentricity and unintelligibility of their work, find the dawn of a new gnosis.

They create a "new world," limited to the few and subject to the tyranny of a handful of the initiated. There is no myth of

17. Gabriel Marcel, *Los Hombres contra lo Humano,* Buenos Aires, Ed. Hachette, 1955, p. 211.

the "doomed poet" (Baudelaire, Rimbaud) once so fashionable. Instead, a new myth is born through provocation and excess. The artist expects and is expected to create something new.

As Mircea Eliade puts it, this "constitutes in art the absolute triumph of the permanent revolution . . . all innovation is declared beforehand, by decree, to be as brilliant as a Van Gogh or a Picasso, whether it be a commercial advertisement or a can of sardines signed by the artist."[18] Nor are the critics and collectors averse to the trend; on the contrary, they form a common front with the artists and the public. Nobody wants to admit that he fails to understand the relevance of a new artistic experience.

Instant mythology has captured the imagination of the modern elites. The phenomenon is well described by Eliade: "On the one hand, one has the sensation of a rite of initiation, a rite that has almost disappeared from the modern world; on the other hand, one impresses on the 'others,' the 'masses,' that one belongs to a secret minority; not to an aristocracy (the modern elites lean to the Left) but to a gnosis that manages to be simultaneously secular and spiritual, opposed equally to traditional values and organized religion. . . . One dreams of being 'initiated' in order to penetrate the hidden meaning behind the destruction of artistic languages, the 'original' experiences that seem at first glance to have nothing in common with art." Eliade, when speaking of the triumph of the permanent revolution related to these innovations, implies that political currents run alongside this art.

There are two types of criticism that attract readers to certain Latin American writers.

One kind neglects the aesthetic aspect of literature, on the assumption that it has been previously handled; instead, it concentrates on the significance of the work on a deeper level—esoteric or not, it deals with man and society in a spiritual context. This criticism shares the objectives, and consequences, proposed by the author in question, in proof of which

18. Mircea Eliade, *Myth and Reality,* Madrid, Guadarrama, 1968, p. 206.

analytical studies—such as structuralism—are provided to add weight to the grand designs.

Terms such as "meta-language," "synchronized presence," "translinguistic plane," "mythico-symbolic system" are used by the writer to reach the "image of a new man," since Fuentes "intends to influence the complex social and cultural crisis in South America by presenting a leading humanistic vision." The structuralist method is used, but only if it does not impede "evaluating these works as representative of the Latin American problem."[19]

Another type of criticism, of the traditional sort, is employed by Luis Harss, Zunilda Gertel, and others in their analysis of Latin American literature.

How does one arrive at the "image of the new man"? It is quite different from St. Paul's concept although at times, in a deceptive feint, it caricatures him.

We quote from the Epistle addressed by the Apostle to the Ephesians, Chap. 4, 17–24, in the New Testament, translated from the Greek Bible:

"This I say therefore, and testify in the Lord, that ye no longer walk as the Gentiles also walk, in the vanity of their mind, being darkened in their understanding, alienated from the life of God because of the ignorance that is in them, because of the hardening of their heart; who being past feeling gave themselves up to lasciviousness, to work all uncleanness with greediness. But ye did not so learn Christ; if so be that ye heard him, and were taught in him, even as truth is in Jesus; that ye put away, as concerning your former manner of life, the old man, which waxeth corrupt after the lusts of deceit; and that ye be renewed in the spirit of your mind, and put on the new man, which after God hath been created in righteousness and holiness of truth."

It is vitally important to keep this passage in mind, so that when our contemporary prophets advocate a total revolution

19. Liliana Befumo Boschi and Elisa Calabrese, *Nostalgia of the Future in the Works of Carlos Fuentes,* Buenos Aires, F. García Cambeiro, 1974, pp. 10, 91.

and tell us that their concept is Christian, we are not deceived by their hypothetical and futuristic theology.

"Cortázar and Fuentes," according to Boschi and Calabrese, "share certain essential ideas on how to create the new man. Cortázar arrives at it through 'the creation of a private language of conceptual content which facilitates a communication beyond logic and beyond the processes of Western thought.'

"Fuentes proceeds through a 'verbal alchemy,' which resorts to an 'alternating technique' and is similar to that of Cortázar. This is why Fuentes himself says that he feels compelled to create a revolution on the aesthetic plane: 'To found a new order and create a new language of panic, renovation, disorder and humor.'"[20]

Fuentes delves into myths, especially pre-Columbian myths, and Cortázar into the ineffable beyond. Pre-Columbian myths and "the beyond," or "the other side," often run parallel to each other. Both writers have declared themselves Marxists in the political field; but, without abandoning its precepts, they reach beyond. Fuentes dedicated the first edition of his novel, *The Death of Artemio Cruz,* to Lázaro Cárdenas, "because," Fuentes said, "Lázaro Cárdenas opened the way to a popular government, a Mexican socialism in which Marxist thought rules every act of government."[21]

Documented and profound explanations of the function of myth are found in the works of Befumo and Calabrese, as well as its appropriation of reality through symbolism, its union with primitive man, and its effects on contemporary man.

The primitive myth, with its ritualistic and religious roots, nourished the American aborigine and put him in touch with reality. The growth of rationality as seen in today's man was accomplished by forces of disintegration. "The loss of myth deprives him of something vitally necessary: the experience of the sacred. Thus arise our myths, in secularized form, which nevertheless fulfill the same basic function: the wellspring of life, individual and collective, whether political, economic, ar-

20. Ibid., p. 171.
21. Luis Harss, op. cit., p. 358.

tistic, or at leisure. These modern myths fulfill the same functions of old, polarizing in contemporary man the powers that give meaning to life, causing him to transcend the daily grind and to reach the numinous."[22]

We should, however, be careful concerning certain categorical observations of these authors. What did the arrival of the conquistador mean to the primitive natives of America?

Liliana Befumo Boschi and Elisa Calabrese explain it thus: "The awareness of myth had to give way to the European reflective conscience, which caused a separation from what had been sacred, the ritual in which one can be submerged in timelessness: the myth. The arrival of the Europeans—identified with reflective thinking—had the effect of alienation, then and for the future, because they eradicated the myth; a high price enacted on the primitive people by the arrival of the conquistadors. The natives were mythically disinherited and the discovered world became the patrimony of philosophy.

"Contemporary man, tired of the limitations of reason and the image it gives of himself, has begun to search by various means for the totalizing unit between himself and the world."[23]

This suggests one of the characteristics of the new man as found in Latin America, and the attempt to rediscover his primordial myth of innocence. And it is also an essential fallacy that distorts the reasoning process.

Christian symbolic thinking, not rationalism, displaced mythical thought in America. We have written elsewhere: "total reality affects the Spaniard more than the rational inquiry into reality . . . We believe that the transcendental rather than the metaphysical appeals to the Spaniard. This is the Iberian equation."[24]

The Spaniards who came to America as evangelizers, sailors, soldiers, or administrators are all included in this category.

22. Odo Casel, *The Mystery of Christian Culture,* San Sebastian, Dinor, 1953, p. 98.

23. Liliana Befumo Boschi and Elisa Calabrese, op. cit., pp. 17, 18.

24. Alberto Boixadós, *Spain Between Europe and Latin America,* Buenos Aires, Arete, 1973, pp. 79, 89.

Faith in the invisible God is one alone and remains unchanged now and for all time to come. What does change is the way in which faith moves history, for man does not always practise his faith and in the same manner. The importance of faith, specially Spanish faith, which takes priority over the rational order and its influence in the American continent, is sublimely ignored by the authors and critics of the new novel. So much so that Carlos Fuentes paradigmatically exclaims: "García Márquez destroys these a priori idiots in order to proclaim and control the right to imagination, which knows how to distinguish between mystification, wherein a dead past tries to pass for a live present, and 'mythification,' wherein the live present recovers the life of the past as well."[25]

The mythical dimension bypasses the ways by which the Christian faith has made and continues to make the history of America. The destruction of the faith—victim of a rational ignorance or of being demoted to the realm of the myth—impedes an understanding of the role of the Spaniards and of the quality of the spiritual gifts they brought to America; it has led to the claim that the chains of Spain's colonialism can only be shed through revolution.

Since authentic and valid Christianity has not been preserved, it is a degraded form of the faith, understood as being the real thing, that is under attack.

In Carlos Fuentes' second novel, *The Clear Consciences,* the action occurs in a city called Guanajuato which he describes as a "bastion of provincial conservatism, whose aristocratic inhabitants founded the most venerable Jesuit university in Mexico, and who live like haughty guardians of the quintessence of the old Spanish style." Carlos Fuentes makes no distinction between Catholicism and Jesuitry.

Far from pointing out the erroneous direction taken by the Church in its Baroque tendency to create a topheavy superstructure, Carlos Fuentes wants to destroy the entire edifice of the Church by lumping it all together in a simplistic judgment.

25. Carlos Fuentes, *The New Latin American Novel,* México, Joaquín Mortiz, 1969.

Even worse, the core of Catholicism is identified as obscurantist and hypocritical—to combat the one is to combat the other. And he uses this ruined Christianity in his later novels as only one ingredient in a world where myth, revitalized as an eternal present, nourishes the new alienated society.

If Fuentes intended in this novel to demolish real Christianity by consciously or unconsciously clouding over the integral vision of its Mystery and its message, in his successive novels he attempts to revert to a mythical environment. This, through revolution, will lead to a new society which, as he himself admits, will not be far from demonic.

If the creation of a new man entails this goal, as seems clear, then needless to say, the matter assumes serious proportions.

The vehicle for this undertaking is the novel, which "under the guise of an easy form to follow, places within everybody's reach the archetypal myth where the hero, having overcome multiple sufferings and ritual obstacles, goes on a permanent search for 'the center of things.'

"The archetypal space of the myth is not simply a continent but an absolute place. The repetition of sacred rites will allow contemporary man to enter an eschatological time-frame where the same things constantly become new, and the human becomes a contemporary of the cosmogony."[26] In the case of Fuentes, this cosmogony is the Aztecs', who will, among others, participate in the rebirth of the new man.

Carlos Fuentes has structured his novels "with some of the most tortuous techniques of the North American novel";[27] nevertheless, underlying it, there is a profound and intense life which, given the right password, will enable man to cross "to the other side."

"The reader will be able to approach directly the constant and vertiginous flow of a mythical future, in which the gods and pre-Hispanic civilizations are in a permanent struggle to emerge, those unpleasant mythical Greco-Romans who refuse

26. Gusdorf George, *Myth and Metaphysics*, Buenos Aires, Nora, 1960, p.80, cited by Befumo and Calabrese.
27. Luis Harss, op. cit., p. 360.

to be forgotten, the Judeo-Christian tradition, and an inner rebellion that wishes to transcend them all and create a new meaning for the new man who must die in order to be reborn."[28] This final non-serviam is the attitude that seals the destiny of the new man.

A paragraph in a book by Graciela Maturo, on García Márquez, includes him in the pursuit of the founding of the new man:

"Socio-historism is not uninvolved in the mythical world, nor does it relegate it to the fictional realm, since both are levels of total reality, the historic and concrete being the phenomenal and apparent levels, while the aesthetic and spiritual are the deeper levels that give it meaning."[29]

Commenting on Fuentes' novel, *The Death of Artemio Cruz,* Liliana Befumo and Elisa Calabrese point out the many meanings in the myth of the Mexican Fiesta—where all is permitted, where seemingly separate spheres in the socio-historic perspective become integrated, and where the Aztec myth intermingles with the Christian tradition. With admirable technique, Fuentes enables us to participate in the abolition of secular time and simultaneously recreates a primordial Time, with Artemio Cruz as its future and undisputed symbol.

Just as jazz acquired liturgical dimensions for Cortázar, in Fuentes' *Change of Skin,* "the Beatles appear in 'the Fiesta' as a modern symbol, and do away with the false dualisms upon which our civilization is based. It is they who, through music and dance—ancestral components of the rite—put an end to reason and conflict. They are the sum of all who have used heterodoxy to abolish norms and rigid regulations; they are the creators of *a new order.*"

As Fuentes says in *Change of Skin,* "The Beatles leap free, up to their heaven, and slowly descend like Antaeus to touch down on the new earth where they are neither men nor women, neither good nor evil, neither corporeal nor spiritual,

28. Befumo and Calabrese, op. cit., p. 24.
29. Graciela Maturo, *Claves Simbólices de García Márquez,* Buenos Aires, F. García Cambeiro, 1972, p. 65.

matter nor substance, essence nor accident; there is only the dance and the rite, the fusion and the mask constantly growing around everything . . ."[30]—close to a liturgical rite, as with Cortázar.

What emerges from Fuentes' writings, as interpreted by Befumo and Calabrese, is the demotion of Christianity to the category of myth and the distortion this entails.

"The Güero is doubtlessly Christ," Befumo-Calabrese write, "and once again the imposition of Aztec myths on Christian faith becomes apparent in the work of Carlos Fuentes. The reference to Christ does not, however, respond to classical canons; on the contrary, a special effort is made to show a totally unconventional image, which if not fitted into the mythological frame may appear frankly offensive and heterodox.

"Jesus Christ is the archtype of the new order and thus he was dangerous to the established order which was not disposed to accept him. He was the first rebel and he succeeded in integrating all the qualities of life, because he held a code of conduct which put him constantly at risk, though he allowed nothing to hinder him."

The figure of the Son of God drawn here could not be more opposed to the authentic image of Christ. Rather, the image resembles a battering ram poised to destroy our civilization. The following is even more enlightening:

"What they do not recognize in the nailed Güero is that he was the first psychopath, the first of the truly disoriented in history. Today he would be riding a motorcycle and dancing the watusi in order to shock the sanctimonious; and all that about raising the dead, walking on water and fraternizing with loose women was his way of giving scandal because there is no better way of gaining notoriety . . ."[31]

"*Cambio de Piel,*" writes Befumo-Calabrese, "is without doubt where the name [of Christ], without being mentioned in the text, is implied most clearly . . . especially in the scene of his birth [in a brothel] where all the elements of a de-

30. Carlos Fuentes, *Change of Skin*, México, J. Mortiz, 1967, p. 237.
31. Ibid., p. 263.

monic ritual point to an act of opposites complementing each other . . .

"They are the symbols of the occult, of that half of the being which has been obliterated by the obligation to accept the good and the proper. . . . In order to arrive at the mythical concept of the new world, we must mention all that was lost, and include it in the totality of the forces . . . 'The hope of the real revolution.'"[32]

If we do not clarify and define the essential concepts so indiscriminately jumbled here, it will be difficult to interpret both Fuentes and his mentors. The mingling of American mythology, paganism, and Christianity, is not original, neither in life nor in literature. Herman Hesse, the popular European writer of the twenties, rediscovered by the hippies of the sixties, in his famous *Demian* exhumes the old god Abraxas, in whom "the opposites are complemented" and who symbolizes the merged forces of good and evil. We know the overwhelming and destructive effect the book *Demian* had on many young people of that generation who considered it their Gospel.

Sinclair, the young storyteller of the book who tries to identify himself with us and all adolescent readers, is under the influence of Demian who speaks to him, and to us: "The fact is that this God, of the old and of the new covenant, may be an excellent conception, but He is not what He really ought to be. He is everything that is good, noble, fatherly, beautiful, sublime and sentimental certainly! But the world consists of other things which are simply ascribed to the devil. And this part of the world, at least half, is suppressed and hushed up. Just as they praise God as the Father of all life, but do not describe the sex-life on which all life depends, they declare it to be sinful and the world of the devil! I have nothing to say against honoring this God Jehovah, nothing at all. But I think we should reverence everything and look upon the whole world as sacred, not merely this artificially separated, official half of it! We ought then to worship the devil as well as God. I should find that quite right. Or we ought to create a God, who would

32. Befumo and Calabrese, op. cit., pp. 83–85.

embody the devil as well, and before whom we should not have to close our eyes to avoid seeing when the most natural things in the world take place."[33]

It is unclear whether the vaguely insinuated homosexuality in *Demian* is to be taken as one of "the most natural things in the world." Years later, while in school, Sinclair receives a message from Demian that says: "The God is called Abraxas." This occurs during a class where a young professor, in explaining Herodotus, says:

"We must not imagine the ideas of these sects and mystical corporations of antiquity to be as naive as they appear from the standpoint of a rationalistic outlook. Antiquity knew absolutely nothing of science, in our sense of the word. On the other hand, more attention was paid to truths of a philosophical, mystical nature, which often attained to a very high stage of development.

"Magic in part arose therefrom and often led to fraud and crime. But nonetheless, magic had a noble origin and was inspired by deep thought. So it was with the teaching of Abraxas, which I have just cited as an example. This name is used in Greek charm formulas and it has been supposed to be the name of some evil spirit with supernatural powers, such as some savage people worship today. But other hypotheses ascribe to Abraxas a much wider significance, seeing in the name that of a divinity on whom the symbolical task was imposed of uniting the divine and the diabolical. These words reechoed in me. They were already familiar to me from a talk with Demian in the latter part of our friendship."[34]

Later, as in a dream, Sinclair encounters Abraxas.

It is necessary to point out how Herman Hesse distorts Christian thought. Demian's (and Hesse's) rebellion consists in that, while accepting the concept of Evil, of the Fall through Original Sin, it rejects Grace and Redemption. Herein lies the root of pride.

33. Herman Hesse, *Demian,* Buenos Aires, Ed. Argonauta, 1946, p. 62.
34. Ibid., p. 93.

In order to pay simultaneous homage to Evil, to the Devil as well as to God, he wants to amend God's Law—the Way, the Truth and the Life. With cleverly and beautifully manipulated arguments, though childish and rather Puritan, he tries to convince us that Catholicism disregards the most natural things in the world.

This glimpse into Hesse demonstrates Fuentes' lack of originality—his pagan-mythical pursuit—and the danger and destructiveness of his utopian presumption. It is precisely this mixture of the pagan and the Christian, of the mythical and an unconventional Christianity, that nourishes the hopes of "establishing our national and Latin American identity" by "questioning the motives that kept us bound to a burdensome cultural dependence," Befumo and Calabrese write. And they continue:

"Carlos Fuentes defines the task of this intent. He returns to the origins and from there, through an arduous process, he finds the golden thread that will lead him through the labyrinth to the revolution, the only way to create a new man for an equally new epoch . . .

"A profound longing is engendered for a future which should be a permanent Now, enriched by a life-giving past, in a meeting which will crystallize in a sanctuary where communion and the Fiesta can be celebrated together. There will gather all that is necessary to shape the totalizing Unity—the first and the final—where both the individual and the collective will be affirmed.

"But the establishment of this new order will depend on the equilibrium achieved between the visible and the occult forces and, to arrive at this, according to Fuentes, one has to rely on the 'permanent revolution,' the daily conquest of the eccentric margin of truth, the creativity and the disorder which oppose the orthodox order.

"One of the ways to achieve the revolution is through art. By means of art, a different reality, timeless, mythical, is created. It is there, in that sacred area, that the sought-after unity is found. Everything is integrated without loss of meaning . . . in the new sanctified place, where the rites will be per-

formed that will unite us in a new concept of life, superimposed by an everyday reality.

"The recovery of the Word, the transfiguration of man who must undergo a long initiation—this will lead him to the discovery of the essence of the spirit, and through this to the transformation of his place in the world. Fuentes reconquers the mythical time-space, and through his writing creates a symbol to which he gives a new name."[35]

Much space has been devoted to the commentary of Befumo and Calabrese because their profound understanding and their participation, willingly or otherwise, as mentors in the cocreative work of the novelist help us to understand the attitude of the writer concerning the great issues in question: God, Christianity, the Latin American man, language, myth, utopia ... all of which obviously go beyond the merely aesthetic and literary aspects of the great foundation-laying venture of the writers we are analyzing.

This venture has been and still is successful. It is swaying hundreds of thousands of unwary readers and students who because of their weak, lukewarm Christian education are easily "converted." Since the venture is strengthened by every revolutionary convert, it reaches much deeper levels than those Blanco Amor denounced in his article mentioned above.

It is relevant to differentiate between the Christian and the mythical concepts of time, just as was done with the theological aspects of the "New Man" in the Epistles of St. Paul. "When I want to know the latest news, I reread the Apocalypse," Leon Bloy used to say—good advice if one wishes to view the entire panorama of what is happening in these presumptuous times in which man is deified but in which ideologies are wrecked, certain "absolutes" are shredded to bits, and strong powers evaporate into thin air. Obdurate and impregnable nihilists declare that we are oversaturated with culture, that we should return to the primordial time-space of mythology.

Leon Bloy searches for the most profound meaning in history, and while newspapers talk of rising empires and civiliza-

35. Befumo and Calabrese, op. cit., p. 187 on.

tions in their death throes, he knows that what really matters is the eternal salvation or perdition of man.

Leon Bloy understands that the Apocalypse is the book that offers the symbolic panorama of the whole of history. Some definitions should therefore be clarified in order to help us grasp the Apocalypse, "which, as the hermeneutics of the history of Time and of the end of times, provides the key to an understanding of the relationship between 'Axial time,' 'Fullness of time,' and the 'Consummation of time,'" according to Héctor Mandrioni. He goes on: "Axial time is the temporal process of humanity as it passes from myth to the logos. The advent of the logos is irreversible. Today it is surrounded by controversy; on the one hand, it is stripped of its best substance and, on the other, it is given to wishful thinking concerning a retrogression to an amoral innocence. But the Greek logos opened up a future of an 'infinite task' that cannot be locked into an absolute system, much less diluted to a subconscious myth.

"The center—the Axis—of time can be understood from the Bible to be one of the conditions that prepared the cultural repository for the redemptive plan begun in Israel and which, with Christ, constitute 'Fullness of Time,' because with the coming of the Word, the messianic promises are fulfilled: And the human logos from that moment on is judged by its power to redeem, which affects the whole of history and launches it toward its final 'Consummation.' The central theme of the Apocalypse is the consummation of time."[36]

With reference to the transition from myth to logos, it should be remembered that "Greek mythology, the mythology fixed by the Greek epic, is not a primitive artistic expression but a late, mature, cultivated result embodying the patrimony of over a millenium of high culture."[37] This explains why the transition from myth to logos was imperceptible, and leads us to believe, along with Luis Diez del Corral, that while the European spirit

36. Héctor D. Mandrioni, *Notas al Apocalipsis, La Nación,* Nov. 28, 1976.

37. Luis Diez del Corral, *The Function of the Classic Myth,* Madrid, Gredos, 1957.

that found in the spirit of Greece the core of things does not succumb to the esoteric spirit of the Orient or to utilitarian rationalism, much may still be saved.

With this understanding of the importance of the transition from myth to logos it is well to go back to the Apocalypse and remember with Héctor Mandrioni that:

"a) The entire book is marked by a will to know; it has a vision, and an audience to receive the contents. There is an unveiling of the future and of the end, and a compulsion to communicate. Christian thought, always on the brink of being swept away by demonic powers, is vindicated and encouraged in the Apocalypse. The center of this wise unveiling of the ultimate secrets of the world is the point where time and eternity, history and its conclusion, the real actions of men and the plan of God come together.

"b) The Apocalyptic image is not a myth, because there is no returning to the past, to mythological origins. This is not an 'ancestral' nostalgia. As time is consumed and the Second Coming of Christ draws near, what was in the beginning will be left behind.

"c) The Apocalyptic image is not a utopia, because the event that is proclaimed by the symbols and the words are real.

"d) The contents of the Apocalypse are not an ideology, since it is not an illusion or a dream of the future employed to satisfy longing for happiness.

"e) In the light of the Apocalypse the temporal is shown as an interruption in cyclical time."

In the Apocalypse, St. Paul's New Man and the voice of God proclaim: "Behold, I make all things new," completing the historical-divine panorama that has gone beyond all reminiscences or mythological yearnings. Thus, to confuse and mingle myth with Christianity is to misunderstand the real issue, which is the reality of "demythification" wrought by Christ's historical act of Redemption. It is, in a word, to promote the Antichrist.

It would appear, therefore, that the avant-garde writers with whom we are dealing imagine an era similar to that predicted by Yehuda Halevy in 1140 in his *Al-Khazari:* "Christianity

71

and Islam are the precursors and initiators of the messianic era: they serve to prepare mankind for the reign of truth and justice."[38]

This overview of the various approaches to the new man would not be complete without presenting briefly the correlation between structuralism and this effort. And Carlos Fuentes again offers the best example.

"The latest fashions in scientism consist in reducing knowledge to technicalities: labeled structuralism, it is a cultural sign of twentieth-century societies, applied by technocrats who were cradled in Marxism, though it triumphs mostly in the capitalist nations." The common denominator that unites the various trends of structuralism is the rejection of philosophy, history, and religion, the latter having been replaced by various idols.

George Lukács in his *History and Class Consciousness,* a broad interpretation of history, draws a line which, beginning with Marx, stretches to writers such as Jacques Lacan, Louis Althusser, and Claude Levi-Strauss. "The structuralism of the twentieth century, as was well put by Francisco Elías de Tejada, is not a system of thought, but a movement, an activity, a series of positions united more by what they deny than by what they affirm."[39]

According to Jean Piaget's definition of structuralism, certain structural transformations are made outside of time, such as mathematical structures; but others take place in time, such as linguistic and sociological structures. But these structures do not fit into the historic time-frame since their effects are irreversible and therefore excluded from the standard process of history. And herein their connections with myth.

"Structuralism has spread to all the fields of knowledge," writes Víctor Manuel Aguiar e Silva, "but most fruitfully in philology. The path was set by F. de Saussure in his course on

38. Leo Schaya, *The Universal Significance of the Cabala,* Buenos Aires, Dedalo, 1976, p. 14.

39. Francisco Elias de Tejada, *Tratado de Filosofía del Derecho,* Spain, University of Seville, 1974, p. 428 on.

General Linguistics when he separated speech from language
. . . Man is canceled because he is imprisoned by the structure
of the language he uses. According to Jean Marie Auzías in
Structuralism, the 'I' is weakened because real thought is the
thought of language."

Where then, asks Aguiar e Silva, lies the novelty of the so-
called structuralist criticism? "In the focus of the description
and explanation of literary structures . . . This structural de-
scription does not attempt to explain the contents, or the sig-
nificance of the work, but rather to analyze the combinations
of rules that form the basis for the semiotic system of the lit-
erary work."[40]

This leads to the question: why are almost all critical essays
dealing with Latin American literature based on structuralist
methods? There will be talk of macrosociological groups, of
metalanguage, diachronics, synchronization, context, and so
on, all ignoring the "epic process" method of understanding the
groundwork of novel writing.

Levi-Strauss asks that an abstract, a historic and imper-
sonal structural analysis be applied as the exclusive methodo-
logical process to capture the true depth of the structures.

Thus, any reevaluation of the pre-Columbian myth, which
disdains American history, which from its inception has been
one of "submission and servitude," is a natural branch of this
method. It is assiduously used and applied in linguistic and
literary studies in universities around the world, sometimes
with a profound belief in its effects, sometimes from mere in-
tellectual snobbishness.

Elías de Tejada, citing Francesco Remotti, says: "one gathers
from this study that theory is not at the service of the concrete,
but rather the opposite; the study of the concrete depends on
theoretical elaboration. By putting the model before the real-
ity, technique gains primacy over science."[41]

40. Victor Manuel de Aguiar e Silva, *A Theory of Literature,* Ma-
drid, Gredos, 1972, p. 468.

41. Francisco Remotti, *Structure and History: The Anthropology of
Levy Strauss,* Barcelona, A. Redondo, 1973, p. 19.

The structuralist, like the technocrat, is interested in efficiency, in method; destroy reality, dismember it, so as to rebuild it according to a model which could never be anything but a pretense of reality.

Is this not the goal of Carlos Fuentes when he says that "inherited language must be destroyed in order to create a fiction rooted in a Utopia, an Epic and a Myth," which will represent the new American reality and shape the new man? Man, liberated from his previous history, purged of all aberrations, will emerge only by revolution. What kind of revolution? Marxist, of course, because "Marxism is the most wondrous utopia of our epoch,"[42] the Marxism that rides on the pre-Columbian myth to create a new epic which will breed a new man.

As Carlos Fuentes, speaking of García Márquez' *One Hundred Years of Solitude,* said: "it is an authentic revision of utopia, the epic and the myth of Latin America, which conquers, by demonizing, the dead moments of historiography in order to enter metaphorically, mythically and simultaneously into the total time of the present."[43]

This claim by Carlos Fuentes has a splendid documentary value since it explains all the aspirations of the new Latin American literature. His confession clarifies in no uncertain terms the nature of the enterprise, and he speaks specifically of demonization, which is a known characteristic of pre-Columbian mythology. This is exhaustively proved by Germain Bazin's studies of the religious nature of the Aztecs:

"There is another region in the world where demonism is widespread: pre-Columbian America. Nowhere else did it flourish as in the Americas, this sign of blood which is the sign of Satan; nowhere else in the universe did civilized humanity remain longer under the terror of supraterrestial powers; nowhere else did man have a more tragic knowledge of his precariousness in a world in which he felt himself a stranger. There was no reason to be on earth other than to pay blood

42. Thomas Molnar, *Utopianism: The Perennial Heresy,* Buenos Aires, Eudeba, 1970, p. 32.

43. Befumo and Calabrese, op. cit., p. 83.

tribute to divinities satiated with crime; the very sun demanded its daily ration of blood if it were to consent to continue its path; Thaloc, the god of rain, was no less exigent. The terrors of the millenium left a memorable wake for our civilization. One wonders what was the psychology of a people like the Aztecs who every fifty-two years cringed before the specter of the end of the world? Death, a violent death—in battle or under the sacrificial knife—was the only relief from this infernal life. Battles were frequently waged for no other reason than to feed these sacrificial altars where adolescent girls, children and prisoners of war were ritualistically immolated. This is the nauseating legacy of the Aztec civilization."[44]

44. Germain Bazin, *Carmelite Studies,* Paris, Desclee de Brouwer, 1948, p. 515.

CHAPTER FOUR

Aspects of
Central American
Literature

We have observed the methods used by the Latin American "boom writers" such as Cortázar, Vargas Llosa, García Márquez, and Carlos Fuentes, whose writings are full of utopias and myths. These in turn are tangled up with symbolisms of "various traditional origins: Hebrew, Hellenic, Cabalistic, Alchemist, Christian, which show the internal coherence of the message."[1]

The critic Graciela Maturo believes that these "boom writers" are helping the liberation mystique that is making such headway in Latin America.

The man of letters in whose writings the new trends culminate and who sharply denounces Western Christianity describes himself as a Marxist Communist and a Christian. His credentials certify as much. For he is a priest, a writer, and a poet, and his name is Ernesto Cardenal. In his own words: "Poetry interests me, yes! That's what I do most, but it interests

1. Graciela Maturo, *Claves simbólicas de García Márquez,* Buenos Aires, Fernando García Cambeiro, 1972; back cover of book. Explanations of the sentence appear on pp. 54, 85, 97, 101–3, 105, 141.

me the way that poetry interested the prophets. It interests me as a means of expression, to denounce injustice and announce that the Kingdom of God is at hand. This is why whenever I get a chance to preach before a large public—and it is not always possible—I do it mentioning the word Communism, and I speak in its favor. Furthermore, Communism is deeply Christian."[2]

His confession could not have been more full nor more frank. What remains unclear is, of course, his true meaning. For he contradicts more than 2000 years of Church tradition which he, along with some other "boom writers" and their critics, dismisses as the conventional Church. This sort of statement manages to create tremendous confusion and introduces error.

What seems strange is that this should come from a monk and a priest, until, that is, one studies his spiritual itinerary.

Ernesto Cardenal was born in Nicaragua in 1925 of a prominent family. Having completed his high school studies in a Jesuit College, he went to the University of Mexico to study the liberal arts—philosophy and letters—and later went on to the University of Columbia in New York City. In 1954 he took part in Nicaragua's April Revolution against Somoza and managed to escape; from then on, his poetry became a voice for social and political denunciation (*Hora O, Epigramas*).

In 1957, he surprised everyone, especially his close friends, by joining the Trappists in Gethsemane, Kentucky, Thomas Merton's monastery. "The work conceived during the years with the Trappists, *Vida en el Amor* [*Life Within Love*], witnesses to his poetic maturing as well as to a new theological understanding."[3] After two years, he left Gethsemane and spent another two years with the Benedictines in Cuernavaca, Mexico.

This period of his life is interesting if one is aware of what

2. Ernesto Cardenal, *La Santidad de la Revolución,* Salamanca, Spain, Sígueme, 1976, pp. 56–57.

3. Ibid., p. 12. Introduction, pp. 9–16, by Hermann Schulz. The chapter "Conversation in Solentiname" deals with Ernesto Cardenal and Hermann Schulz.

went on at Cuernavaca. The Holy See finally had to dissolve the Benedictine community when it was indisputably proved that the monastery was a center for Marxist indoctrination of priests and seminarians who went on from there to preach in various South American countries. Gregorio Lemercier and Ivan Illich were suspended, and there was quite a sensation when several female psychologists were admitted to the monastic community. The life of Ernesto Cardenal, though he was perhaps already party to the secret, shows that he did not escape the indoctrination and infiltration of the Church, a corruption from which South America is still suffering today.

From Cuernavaca he moved to Medellín, Columbia, where he completed his studies in the seminary. In 1966 he arrived with two Colombian seminarians, William and Carlos Alberto, to the island of Solentiname on the Great Lake of Nicaragua and founded a community. Carlos Alberto soon left, and William married. Since he wished, nevertheless, to return to the community at Solentiname, Cardenal decided that "it might be a good idea to admit married couples to the community, it might revitalize monasticism."[4]

In June 1972, the writer Hermann Schulz visited and interviewed Cardenal, who had recently returned from an extended tour of the three socialist Latin American countries of the time, Cuba, Chile, and Peru, and had reported his findings in his book *The Sanctity of the Revolution*. Some of the books' concepts had already appeared in his *In Cuba,* which had spread Cardenal's influence among the students and intellectuals in Argentina where it had been published. A sampling follows:

"For me the Cuban experience was a revelation. I realized that Marxism is the solution, the only solution for Latin America. My days in Cuba were like a revelation to me, which afterward matured through reading and conversations with a number of travelers who arrived at Solentiname—most of them revolutionaries—from the different countries in Europe and South America, and from the United States.

"And I and the rest of our commune became more radical in

4. Ibid., p. 23.

our conversation, our reading, and in what we experienced in Latin America—the Chilean process, the Peruvian process, the revolutionary movements in all the countries. The change we have experienced is in accord with the change seen all over Latin America which is moving toward the Left, the extreme Left—the young, the intellectuals, the Church, even the bishops. We are changing together with history, according to circumstances. The United States itself is in the process of change. This means that we are simply in tune with present changes, with the change of mentality which is taking place in the whole world, in all the youth who represent the new world.

"One can say that all of Nicaragua's thinking youth today is of the extreme Left, they are interested in social and political problems. Even fifteen-year-old girls, educated in convents, devout Christians, are today followers of Communism, and find no contradiction between the Marxist revolution and Christianity."[5]

A fifteen-year-old girl cannot, of course, delve deeply into this subject. If she finds no conflict between the two, it is because she is ignorant of both Marxism and Christianity.

What, then, are the essential characteristics of the new man that the socialists are trying to create? Cardenal answers: "The new man is a man divested of egoism, a man that lives for the sake of others, to serve the rest . . . In Cuba, everything in a factory is decided by vote, by elections. The members of the party who exercise power are elected in the factories, the workshops, the work centers, elected by the people, even those who do not belong to the party. So I think that in Cuba it is the people who hold the power."[6]

The question leaps out: why then are there no general elections to choose the mayors, the governors, or even the president?

From among the youth movement of the Left, the "Jesus people" and the "hippies" questioned Cardenal about religion, and he replied: "For me religion is superceded. Religious forms

5. Ibid., pp. 27–28.
6. Ibid., pp. 31, 35.

really belong to primitive societies. Christianity in itself is not a religion but the practice of love, a realization of human fraternity. That is the true religion of the Christian.

"The rites, the liturgy, the religious forms can serve this purpose and can be good in this sense. But if they do not do so, they do not interest us. Religion in Latin America can still be useful. The popular religion, the processions and practices of the people, can be useful for the liberation. However, the moment will come when the people will outgrow this religious stage.

"The 'Jesus people' are a retrogression to the primitive forms of religion, they remain on the surface and they are apolitical. The 'hippies,' on the other hand—at least some of them, the real ones—seek mysticism and contemplation. But Christianity itself is already overcoming that ritual stage. The official Church almost always rejects all that is good; in his time, Camilo Torres was also rejected."[7]

Schulz concludes his interview with the following question: "Is there not a contradiction between the biblical God and the Marxist-Leninist concept of God?" Cardenal responds saying that "for me the God of the Bible is also the Marxist-Leninist God. There are two types of atheism and two types of materialism. The God of the Bible is the God who is incarnate in man. He is a God we can only understand through love for our fellowmen. We cannot have direct contact with Him. St. John calls Him 'the God whom no one has seen.' Marxist opinion seems to me very similar to St. John's; it states that 'no one has seen God.' The real atheism, the real negation of God, for me, is represented by the Esso Company and Standard Oil. That is the true atheistic materialism. The Dow Company which makes money manufacturing napalm is the true negation of God."[8]

The unfeeling sort of capitalism that controls these and other businesses like them has no trace of Christianity in it, nor does it pretend to have. What surprises, however, is that a

7. Ibid., pp. 41–42.
8. Ibid., p. 52.

person like Cardenal does not realize to what extent many of these multinational companies support the worldwide spread of Marxism. The statistics of exports by these companies show the extent of their technological and material aid to the Soviet Union, not least among these the financial loans proferred publicly and infamously by banks like the Chase Manhattan.

This business is not as simple as it seems, and Ernesto Cardenal must realize it. But it does not hinder him from equating St. John's "the God whom no man has seen" ("the invisible God") with the Marxist-Leninist "no one has seen God." It is the sort of simple fallacy that can convince fifteen-year-old girls. It can also seduce adults if they are not conscious of the empirical twist given the phrase and fail to realize that this type of philosophical thinking can only acknowledge the existence of the material world. St. John's phrase, of course, refers to knowing God through faith.

Ernesto Cardenal has ended up by becoming the spiritual guide to the Marxist-Sandinista government now in power in Nicaragua, its minister of culture. (TV viewers saw him chided publicly by the Pope during his visit to the country.)

In July 24, 1979, *La Prensa,* the Buenos Aires newspaper, published a significant report which, toward the end, carries a rather disquieting piece of news: "Ernesto Cardenal is a man of letters, more precisely a poet, whose work has become known not only in the Spanish-speaking countries because his usage of the language has an undeniable intrinsic value, but also abroad, having a wider range than any Spanish or Latin American writer whose work is of comparable merit. This is due to the incessant propaganda of the Left on both sides of the Iron Curtain to propagate his work.

"In an island on the Solentiname Archipelago of the Great Lake in Nicaragua, he headed a peasants' colony where he established a kind of indoctrination center. There was nothing so coarse as the training of guerrillas or terrorists. But nor does anyone deny that Cardenal is a Communist, and he himself admits that Castro's Cuba is a model he would like to see repeated in the rest of the continent.

"In this respect, one of the most prestigious Colombian

newspapers reported some declarations made by Cardenal yesterday, which we have no reason to doubt. The new minister spoke of a new 'constitution which, though prohibiting assassination, would contemplate reinstating the death penalty for those who are found guilty of grave crimes by a people's court.'

"We do not like that small addition, '*by a people's court.*' We do not like *people's courts,* we prefer the justice of the traditional courts. Obviously, we cannot help remembering Castro's *paredón*—the execution wall. Though this should be obvious, for the new minister of Rubén Darío's country is a fervent admirer of Castro."

This disturbing news is worth considering, because Cardenal's life shows that whatever he says has a deep effect on the rest of Latin America. Combined now with power, his dialectic is difficult to warn against. The mere fact that this author is a "priest-monk" makes his word carry an incredible weight in Latin American countries.

The second part of his book *The Sanctity of Revolution* contains an article entitled "Marxism with St. John of the Cross" that paraphrases an expression by the French Communist Roger Garaudy. An example: "The message of the Bible is totally Marxist, even in what pertains to religion." And farther on: "In Latin America there is not only a Marxist theology, but a mystical Marxist theology is also beginning to appear." He concludes the book with some "Poetry of Christian-Marxist Inspiration," which, if somewhat slogan-ridden, is seductive.

Obviously, to fabricate a union between Marxism and Christianity means to destroy the rocks of Christianity. Cardenal would say that "without Christianity, Marxism would not have been possible, and the Old Testament prophets are the forerunners of Marx . . . Now is the time to change society and harvest the last fruits of the Gospels."

This time the incitement to destroy does not come from a lay writer but from a monk who has completely subverted the sense of his mission. Since he considers Marxism neither of the Devil nor intrinsically perverse, he can look with favor on the possibility of ordering the firing squad against Christians who refuse to bow down to the Marxist ideology.

The Process in the United States

Only a perfect understanding of culture, which was created during the development of the human race, and its transformation, will permit the creation of a revolutionary culture.

Lenin[1]

Philippe Sollers has this interesting comment to make about the author of *Ulysses,* James Joyce: "I don't think that Joyce has attained his importance because he was an 'avant-gardist' or a 'modernist.' The reason for Joyce's importance lies in his work—and his is a revolutonary text, a revolutionary work—which was general, something that covered an enormous field in our civilization's history. Joyce is important, not only because he created 'linguistic disturbances' nor because of his obsession with twisting the order of words, or changing and condensing the rhythm of phrases, and so on. He is revolutionary because he wrote in his capacity as a product of a culture that had percolated through St. Thomas, Giordano Bruno, Vico, and that resulted in a precise knowledge of the Middle Ages.

"It must always be remembered that a problem does not spring from a purely formalistic view but in relation to history,

1. Philippe Sollers, *Literatura, Política y Cambios,* chapter: "La escritura: función de transformación social," Argentina, Ed. Caldén, 1976, p. 115.

considered, as it were, from the angle of its transformation. This formal transformation should not be solely 'modern' or 'avant-garde'; it should reflect the whole extent of the historic curve of civilization. This is the case with Joyce and Artaud."[2]

This statement, pure vintage thought, has great importance for it refutes the simplistic arguments of those who believe that subversive literature is limited to daring, new, and revolutionary ideology. Joyce's "revolutionary work" could very well have come to be without his being fully conscious of its importance. Sollers' opinion is corroborated by Lionell Trilling, a prestigious American liberal writer, who in *The Liberal Imagination* and *Beyond Culture* examines modern literature with well-grounded reasoning. He was at one point a staunch supporter and defender of modern literature.

A critic has said that Lionell Trilling personifies the subculture of big city intellectuals—in this case New York—characterized by the intensity of its involvement with ideas, its radical secularism, and its participation in the ideological conscience of modern political life. He was convinced that the formal attitudes of literature, when taken seriously by the reader, contain the germs of a new mode of behavior and of changes in living, with their many consequences. Trilling affirms that the great writers of modern times, such as Dickens, Dostoyevski, Joyce and Kafka, saw "modern culture as a kind of prison," a place where modern man finds fulfillment through the experience of "estrangement."[3]

What should be pointed out about Trilling is his courage in undertaking, despite the pressure of his times, to reexamine "the antagonistic purpose, truly subversive, that characterizes modern literature." One should pause and examine the ways in which the revolution is encroaching, ways about which frequently we have not the slightest idea.

It is not a question of indiscriminately banning this literature, but it ought really to be examined at various levels with

2. Ibid., p. 97.
3. Lionel Trilling, *Más allá de la cultura,* Barcelona, Ed. Lumen, 1968.

due warning of its pernicious influence, much as if it were a dangerous disease. A cure is, moreover, available, for the best antidote is beauty and truth. Though obviously, under certain circumstances, this kind of literature should be banned.

For besides the revolutionary militants who promote this literature and the "useful idiots," there is another category of writers who, while using traditional means and abstaining from the abuse of language, still produce writing that is emptied of formal content and often tainted by nihilism and skepticism, when not merely sensational. The more their mastery of their craft, the more harm they do. They largely lack the fiber of the true revolutionary. Instead, they are provocateurs. They are legion and their influence should not be underestimated.

This overview is merely an attempt to identify the sources, often seemingly harmless, which converge to form a formidable torrent of revolutionary literature.

Literature aimed at the adolescent age group does not, of course, escape the new trend. In the past, books for young people were written to entertain, to offer an escape from the problems of real life as found, for instance, in Alexandre Dumas, or Jules Verne. It is well known that much of our outlook on life stems from those books we read in the young years of our life.

Graham Greene in his *Lost Childhood* aptly reminds us that "perhaps only in our childhood do books have a deep influence in our lives." And Leopold Tyrman, in an article "Recreational Literature for Adolescents" in *The St. Croix Review*[4] points out the tremendous change that this type of literature has had in the United States.

"With the proliferation of books," Tyrman writes, "their mass production, entertainment literature has not only become cheaper, but it has also become a significantly greater factor in the conditioning of minds and consciences. To mention just a few examples, we have Jacqueline Susann and Har-

4. Leopold Tyrman, *The St. Croix Review*, Vol. XI, No 4, Minnesota, August 1978.

old Robbins. They and their numerous imitators have produced a change in entertainment literature which, starting with nauseating melodrama and fantastic sensationalism, lead directly to depravity.

"So extreme is their pragmatic cynicism that there is no doubt that preordained ideological forces are behind their success. Adolescents are deprived of the necessary sense of discrimination between good and evil, and of the corresponding possibilities and power of rejection. The writings of the above mentioned authors are so abasing that in comparison Genet would seem a saint. Doubtlessly, it is a formidable threat to social health."

Tyrman concludes his article by pointing out that, should the enslaving influences of this literature continue, the human condition in the contemporary world would be endangered. The baser, destructive tendencies of man are exploited from adolescence onward. The greed of so many, fomented by those with more devious motiviations, makes it very difficult to propagate healthy literature; it does exist, but it has little circulation.

Currently, there exists a rich narrative creativity that opposes the popular destructive current. Some critics, however, make distinctions in this vast narrative field. Here we are talking about the novelistic trends that possess a literary quality and genuinely try to discover and describe the individual or social problems—simple or complex—of the North American nation.

John Gardner, whose literary success began with his rewriting of the epic poem *Beowulf,* belongs to this category. In *Grendel,* the monster opines that true art creates the myths through which society can either survive or die, and that furthermore, our society is in need of such myths. The ethical novel holds up, as models of decent behavior, certain characters whose basic goodness—their fight against confusion, error, and evil in themselves and others—gives intellectual and emotional support to our own efforts.

Gardner's confessed sympathy for Tolstoy is enlightening. Tolstoy's love for living in contact with nature leads to Gardner's prejudice against urban environments, especially New

York. The theme of city versus country has been and always will be a literary motif.

His essay *The Art of Fiction* shows that the author supports the viability of the ethical novel because it creates a "vivid and continuous" dream in the soul of the reader. Consequently, the value of a great novel consists in its power to convert, to improve ourselves and others, while not losing sight of our own faults and limitations.

In the ongoing debate on the contemporary novel, some critics label these statements as conservative. We believe that the literary avant-garde, bent on demolishing ethical and linguistic values, frequently label as conservative any work that tries to defend traditional values. Since their destruction solves nothing, those values, in order to have validity, should be kept alive. This perhaps is what prompted the eminent art historian Kenneth Clark to confess that a great part of modern art leaves him perplexed.

In his posthumous novel, *Michelsson's Ghosts,* Gardner was searching for a higher truth in the America of today, so minutely described by him. But he was not able to consummate his thought. His untimely death weakened the battle of some in our society against evil.

To continue the critical distinctions of the North American novel, we must mention the Nobel Prize-winner Saul Bellow, whom John Gardner called the "indulgent philosopher." Mr. Bellow began by cultivating the so-called ethnic narrative, specially in his early tales and novels, but after writing *To Jerusalem and Back*—an account of his trip in 1975—he realized that "it was just as easy to write about great political matters as about private ones." This led him to a universal approach which, in a way, transcends the purely ethnic novel. According to Bellow, today's writers succumb to handling easy sentimental topics rather than facing up to the great moral questions.

Richard Poirier, the critic, points out in *The Partisan Review* that the author *Herzog*[5] and *Mr. Sammler's Planet*[6] seems to "substantiate, vivify and even propagate a kind of cultural

5. Saul Bellow, *Herzog,* Barcelona, Ed. Destino, 1965.
6. Saul Bellow, *Mr. Sammler's Planet,* Barcelona, Ed. Destino, 1972.

conservatism." Bellow greets these outworn accusations iron-
ically. His own roots are in the Bible, in Shakespeare and
the great nineteenth-century novelists, and they cannot be
lumped together as conservative. "Writing has always risen to
the challenge of explaining the mysterious circumstances of
being."

Bellow received a Guggenheim Foundation Grant (1948–
1950), which enabled him to live and travel in Europe and
write *The Adventures of Augie March,* and between 1958–
1960, he received aid from the Ford Foundation. No doubt the
financial support helped him develop his talent by enlarging
his knowledge of the world, which enabled him to win the No-
bel Prize.

Each one of his novels is a superior form of autobiography.
This can be observed in his latest book, *The Dean's December,*[7]
where he deals with the many failures of the universities in
the literary field. Factors such as the institutionalization of
progressive publications and the assurance of the publication
of the works of professors helped to destroy the independent
literary culture which once existed in the United States.

‖ Since the publication in 1952 of his novel *Invisible Man,*[8]
which became a classic of modern literature, Ralph Ellison has
written only a few essays, short stories, and reviews. He has,
however, been working on another novel, of which a few chap-
ters only have been published. Ellison, it seems, was crushed
by the series of assassinations in the United States, the reality
of which impinged on his projected novel.

The critic Kostelanetz comments that black writers, more
than whites, seem to feel obligated to comment on socio-
political themes. The poet Michael Harper reminds us that
Ellison maintains that writing novels is connected with the
process of building nations, which for him is to rediscover, re-
define, reinvigorate the United States. Ellison is the most elo-

7. Saul Bellow, *The Dean's December,* Harper and Row, New York,
1982.
8. Ralph Ellison, *Invisible Man,* New York (paperback), 1953.

quent spokesman for the Afro-American, and it should be remembered that at a conference at Harvard in 1973 he said that "we are all partially white, and all of you are partially black."

This profound truth which we all feel deep in our hearts brought Ellison many difficulties and even discouragement. He has said repeatedly: "Imagination is integrationist. I am not a separatist, I am unashamedly a 'North American Integrationist'." Curiously, severe criticism has come from the black sector, to such a point that a black student after one of his lectures called him a traitor.

Ralph Ellison raises questions which should make all Americans think. He considers the United States an unformed nation, but he professes an iron faith in his country. It is a faith in the redemption of the United States, an understanding of the hardships of attaining true redemption for the sin of arrogance.

‖ Flannery O'Connor, the Southern writer who died in 1964, will always be remembered in the United States because of her fascinating personality which is reflected in her style and the contents of her short stories and prodigious correspondence. A critic once said that "she was a curious mixture of the traditional and the modern," a most difficult combination in our day, which is under the tyranny of the fashionable and the sensational.

O'Connor personified the Southern spirit in the United States, the spirit that refuses to die, that fights to survive in the midst of a technocratic world. Great spiritual problems, not to mention strange and grotesque elements, intermingle in this writer's soul.

A special muse assisted her rich personality. She knew from her twenty-fifth year that an incurable disease would bring premature death. This helped her to mold her characters in a redemptive, never in a condemning perspective. This path full of lights and shadows, which led her day by day to her death, was illuminated by her conception of the Christian mystery of salvation, evidenced in her ambiguous and complex writings.

These qualities constitute an attraction, rather than a hindrance, for the modern reader.

Two novels—*Wise Blood*[9] and *The Violent Bear it Away*[10]— together with a salty collection of short stories and letters constitute her entire work. In one of her letters she wrote that "in fiction everything that has an explanation should be explained, and the rest is Mystery with a capital M." The Catholic faith shaped her life and her literature.

This feminine writer helps man (in the generic sense) to trust in himself and in God's mercy through courage, the cardinal virtue of Flannery O'Connor. For courage exemplified her life and her work. In this crucial moment of American life, it is important that women value the virtues which make them essential to a world in desperate need of tenderness, comprehension, highmindedness and courage.

9. Flannery O'Connor, *Wise Blood,* New York, Ed. Signet, 1952.

10. Flannery O'Connor, *The Violent Bear it Away,* New York, Ed. Signet, 1960.

CHAPTER SIX

The Theater

Some modern artistic endeavors have their purest sources de-
filed in a coarse and degrading manner. We mean the theater,
the art closest to life, which as Jean-Louis Barrault puts it,
studies our disequilibriums and purifies our lives through hid-
den means. Today, it has sunk to the nebulous, the absurd, the
nothing.

The influence of the theater is instrinsically greater than
that of films and television, given its immediacy and proxim-
ity. In every performance, as Henry Gouhier explains in *The
Essence of Theater*, there is presence and the present. It does
not lend its voice; it lends its being. A painting or a novel op-
erates on the level of the experienced or imagined action of the
one contemplating or reading it, but when an actor comes on
stage, he and his audience become contemporaneous, they live
at the same time—more, *in* the same time.

Theater resurrects lives. Thus Gouhier says that "its mys-
tery resides not only in the actor, but in the factual presence
before the metamorphosis takes place." The immense charm of
presence is indigenous to theater and distinguishes it from the
cinema, for the "cinema," Gouhier goes on, "only speaks to us
through its interposed images; the soul of drama lies in its hav-
ing a body."

The cinematographic image requires the passivity of the
spectators; the theatrical presentation, on the other hand, calls
for participation, which springs from the spoken word. This

93

noble instrument, drama, was used by the ancient Greeks to purge the passions—catharsis—and it has now become a tool with which to change the course of society, to free men from ills which will presumably disappear as soon as the structures are altered, thus bringing them to the full enjoyment of the socialist utopia.

Today there are many theatrical currents, but we will focus on only one of the more controversial, with the assurance that there are still some playwrights who are determined to preserve the Western tradition.

The old polemic raised by T. S. Eliot—that drama is either poetic or is not theater at all—now has some notable derivations, for quite often the Theater of the Absurd rides under the banner of poetic drama. The Theater of the Absurd, as personified by Jean Genet, claims to be a version in dramatic images of Baudelaire's *Flowers of Evil*. The possible variations evoked by this kind of poetry, and consequently of this "poetic drama," are manifest.

Eugene Ionesco defines his work as the attempt to communicate the incommunicable and claims for this kind of theater the status of true poetry. Bertold Brecht was one of the first masters of the Theater of the Absurd, and his work proves that theatrical work stands or falls not in respect to its political content, but by its poetic force which transcends all else.

It brings to mind the statement made by García Márquez: "I believe that the revolutionary obligation of the writer is to write well; this is his duty." Ionesco puts it this way: "To renew the language is to renew the conception, the vision of the world. A revolution consists in accomplishing the change of mental attitudes."[1]

This statement sheds light on the connection between the Theater of the Absurd and politics. For the new theater attempts to involve man in a new humanism, in which Marxism is simply one of the ingredients. But Marxism is not crucial to

1. Eugene Ionesco, *Le Coeur n'est pas sur la Main*, París, Cahiers des Saisons, 1959.

it; it can easily be substituted by Zen, Buddhism, or any other myth.

There is hope, nevertheless, that the stage will be rescued by someone of the stature of Claudel or Bernanos, who, like Shakespeare, Sophocles or Calderón, will nurture the enjoyment of a world illumined by harmony, and by a light that can reach into the dark corners of the soul.

Briefly, then, let us consider the vital richness and literary wealth contained in the Theater of the Absurd, its tremendous contradictions, its black humor, its tragicomedy, its invocations of nothingness—"There is nothing more real than nothing," said Becket—its senselessness, its search for what lies beyond logic, its irrational and transcendental forces, and in the end, let us laugh and weep over it all.

To best comprehend a writer's work, one must understand the attitude of the author toward the most important issues of life: God, man, the interior life, the cosmos, religion, myth, and so on. The world outlook of writers can be gleaned through their published declarations, their signed articles, and through chronologically following their spiritual evolution in their works.

Thus, Jean Genet entered the literary scene with the novel *The Diary of a Thief,* an autobiographical account of his tempestuous and disgraceful life during the many years he spent in various jails and detention centers. Genet, more than any other author, emphasizes the sacramental aspect of his rebellion against all constituted order and society in general, and consequently, in an inverted sense, raises his disobedience to the level of the transcendental.

Arthur Adamov began by writing the most relevant works of the Theater of the Absurd, and ended up writing solid drama with good social sense. Eugene Ionesco, to the surprise of the noninitiated, attempts to rediscover the hidden aspects of tradition. He hopes to take his place in the line running from Sophocles and Aeschylus to Shakespeare.

To study the strange phenomenon of the Theater of the Absurd, it is necessary to document the coordinates by which

these writers operate in the visible and invisible worlds. It offers the reader a guide by which he can find his way through the works of these authors without being side-tracked by anecdotes or by the moving and shocking vagaries of the play, and it should prevent his being carried away in a sea of sentimentality by its peculiar poetry.

Traditionally in Western theater, there has been a code of values by which the spectator or reader knows where he is going (and it pertains in the theater of Sartre and Camus). But the Theater of the Absurd attempts to make the audience lose all sense of direction, so that from a quicksand of disorientation, it will be "purged" and "redeemed."

Though in most cases the dramatic intention and supposed catharsis do not occur, the spectator may nevertheless, under the spell of poetry, succumb to a "spiritual conversion" to strange beliefs. If the reader or the spectator cannot distinguish between myth and Christianity, it is not difficult to shake his principles by inserting a confusing mixture of the two in the realistic situations in a novel or play, along with some stirring poetry and lavish language.

The absurd, the contradictory, the negation in action of what is affirmed in words has always been part of the human state. When, however, man has a clear vision of his mission on earth, the absurd and the contradictory are assimilated and integrated as simple ingredients of a harmonious whole. They have no status, nor are they totally autonomous. In this respect, the absurd has a long-standing tradition.

Lunatics, clowns and buffoons appear in Shakespeare's theater so that we remember that something of each is inside us all, and that it will surface unexpectedly having eluded the steely and fettered world of logic. These characters are nevertheless part of a whole, of a splendid fusion of the poetics, the literary and the real, the conscious and the subconscious, the popular and the vulgar, and consequently, they are an integral part of our lives.

It can therefore validly be argued that the Theater of the Absurd is in the tradition practised by Shakespeare, in whose works the fantastic and the absurd are part of the essence of

96

life: *Measure for Measure, Hamlet, Two Gentlemen from Verona, A Midsummer Night's Dream, Richard II, Macbeth, Lear,* and so on.

But this universe, on the fringe of logic and common sense, was never envisioned as having an autonomous value as exemplary in and of itself.

This task, the destruction of the conventional structures, was undertaken with considerable artistic knowledge by playwrights like Ionesco, Becket, Genet, Adamov, Grass, Albee, Artaud, and most of all, Kafka. His inconclusive tales and novels give detailed descriptions of the nightmares and obsessions of the main character who, moving in an illogical world, tries to reach places which evade him; thus, faced by the absurdity of existence, he is seized by feelings of guilt and anxiety. In *The Trial,* the protagonist, Kafka, is accused of breaking an unknown law; in *The Castle,* the main character is summoned to a place he never reaches.

"The imagery of Kafkian pain," Mario Lancelotti writes, "surging from the loss of contact with reality and guilt feelings, stems from the failure that has become the ultimate expression of the position of modern man. The concept of feelings of guilt, in Kafka's case with deep theological roots, is united to a feeling of pessimism of a religious nature which considers that Justice and Grace are unattainable, and they at different times assume an omnipresent validity."[2]

The sense of guilt in Kafka, stemming from the dogma of Original Sin, excludes any possibility of redemption, and thus his "beings and circumstances struggle in an eternal preliminary."[3] Dostoyevski, on the other hand, while delving into the profoundest depths of the subconscious and making us experience the sensation of the absurd, imbues his work with the possibility of redemption. The absurd is given its proper place, that is, within the human creature whose life nevertheless does possess a meaning.

2. Mario Lancelotti, *De Poe a Kafka,* Buenos Aires, Eudeba, 1965, p. 59.

3. Ibid.

To the Old Testament view, slightly eroded by Kafka, Dostoyevski offers a clearly Christian answer. It is not merely a question of reaching into the deepest reaches of the human psyche, as did Dostoyevski. What is important is the knowledge that man has both a destiny and a mission on earth, and this belief comes out clearly in Dostoyevski's work.

Kafka's *The Trial,* adapted for the stage by André Gide and Jean-Louis Barrault in 1947, was the first to present the theme of the absurd in the twentieth century. Ionesco, Adamov, Becket, Genet, and Artaud, soon followed.

It is not surprising that Kafka broke the ground. For since his spiritual Old Testament heritage could not accept Christian guidelines and his inner time ran in the deep messianic expectation, it was urgent that he find his place in this age and this life. Otherwise, of course, the myth would be reborn. We should not be surprised, therefore, that the Kafkian stories, set in a circular, continual present, are inspired by an anguished yearning for eternity.

Mallarmé in his day had asked for a mythical theater which, contrary to the French rationalist tradition, would be free of any familiar time, space, and characters. His wish was fulfilled in Kafka and all his followers, whose Theater of the Absurd has flourished in a world in crisis. Since all crises imply rebellion and condemnation, we discover authors, critics, and intellectuals, such as Martin Esslin, who believed that "it is impossible any longer to accept distinct, simplistic and generalized values, or *revealed truths;* therefore, life should be faced in its ultimate and inflexible reality.

"In expressing the tragic sentiment of the loss of basic certainties, the Theater of the Absurd, by a strange paradox, becomes the symptom of what probably comes closest to a genuine religious search in our times . . . to find the indescribable dimension: an effort to make man aware of the fundamental realities of his condition, inculcating once more the feeling of cosmic awe and primitive anxiety. . . . Because God has died, above all for the masses . . . who have lost all contact with the basic and mysterious aspects of the human condition; for reli-

gious rituals served as a contact, making humanity a real community, not just a mere array of atoms in a dispersed society."[4]

This is a very important commentary, for it reveals a truth difficult to dispute: without a spiritual binder, man becomes a floating atom. Also affirmed is the religious mission of the new theater, but this religiousity or affinity with the transcendental bears a terrifying anarchist mask.

For the boastful claim of having shown the human condition in its rawest reality obscures the truth of man as a creation of God. If God has died, everything is permissible; and besides, man acquires a totally autonomous role.

The Theater of the Absurd aspires to reclaim the original function of the theater: a platform where man confronts the religious and mythical spheres as did the Greek tragedy, the Christian mystery plays, and the Baroque allegories. The difference, though, is that the latter's theatrical conventions were based on well-known and accepted metaphysical and religious systems, whereas the Theater of the Absurd lacks the backing of any cosmic or accepted value systems.

It fails to "show the ways of God to Man" (Milton). Instead it dwells on the depths of man's personality, his dreams, fantasies, nightmares. Could the Theater of the Absurd have accomplished both? Certainly, but then it would no longer be absurd.

The action of the Theater of the Absurd does not tell a story, rather it communicates a series of poetic images. And because it reflects the personal world of its author it lacks objectively valid characters. It is a-dramatic in the conventional sense of the term. As Esslin says:

"Things happen in *Waiting for Godot,* but they do not constitute a plot or a story. They are images of Beckett's intuition in which actually nothing ever happens in the existence of man,"[5] which has been totally forsaken by God.

The author's conception of language demonstrates one of his

4. Martin Esslin, *El Teatro del Absurdo,* Barcelona, Seix Barral, 1966, p. 304.

5. Op. cit., p. 305.

most decisive attitudes toward life. For the devaluation of language in the Theater of the Absurd matches other tendencies of our times, such as seen in the works of Cortázar and Vargas Llosa. The antilanguage so frequently used in the Theater of the Absurd can also be found in abstract painting and atonal music.

Esslin claims that by placing language in opposition to the action on the stage, by reducing it to senseless chatter, and by displacing all discursive logic in favor of the poetic law of association and assonance, the Theater of the Absurd has opened up a new dimension.

The ordinary man, constantly harassed by the press and commercial advertising, concludes that the barrage of words has nothing to do with reality, and he reads between the lines or is lost among phantoms, in the process losing his faith in language.

Dostoyevski proved that an atheist could write a newspaper article ostensibly praising a bishop and later interpret the same article to a fellow atheist showing how he had in fact fiercely attacked the prelate.

Eugene Ionesco attempts to fracture language in order to reassemble it to a new order and thus reestablish contact with the "absolute," or the "multiple reality." It is imperative that men see anew what they really are.[6] In Ionesco's works this is conveyed by the total failure of communication between human beings.

In *The Chairs,* nothingness is audible. In *The Lesson,* the obstacles to communication arise from language. During a private lesson the teacher seems incapable of communicating anything to his pupil. Language is shown not only as a faulty means of communication but also as an instrument of power. The pupil becomes completely entrapped and, in the end, is finally murdered by the teacher.

As Ionesco explained it: "I have tried to express the anxiety . . . of my characters through the use of objects, making

6. Eugene Ionesco, *Ni un Dieu, Ni un Demon,* Cahiers Renaud-Barrault, No. 23, Mai 1985, p. 131.

furnishings speak, having actions translated into visual terms, transmitting visible images of fear, sorrow, repentance, alienation, by playing with words. . . . I have tried by these means to amplify the language of the theater. Is this to be condemned?"[7]

Ionesco's methods may be the way, but no one can, of course, be sure whether through them man will rediscover his inner self. For it is becoming increasingly important that words recover their meaning so that communication be reestablished. In any case, the alternative to man's rediscovery of his inner self leaves him open to the risk of becoming the toy of all kinds of totalitarianisms.

For Ionesco the dismembering of language is closely allied to atonal music. His work *Impromptu for the Duchess of Windsor* was accompanied by the music of Pierre Boulez.

Speaking of language in *Experiences of the Theater,* Ionesco asserts that he hopes to "force language into a paroxysm. In order to give theater its true dimension, which means pushing it to extremes, words should be distorted to the limit, and language, forced by its impotence and insignificance, should be so construed so as to explode and destroy itself."

Only a poet can validly attempt this. By use of his astonishing powers, Ionesco, in his poetic theater, attempts to communicate the uncommunicable. In *The Bald Soprano,* his first and simplest play, Alain Bosquet counted thirty-six "formulae for the comic," including negation of action, the character's loss of identity, misleading titles for the works, mechanical surprises, repetition, suppression of chronology, loss of memory, interrupted dialogue, and many more.[8] Ionesco also makes good use of comic devices discovered by Flaubert and Joyce, such as clichés and slang.

If the comic element can be defined as a subtle mutation of tension from one area to another, then Ionesco's audiences are constantly goaded by a humor which is both comic and tragic. Are not both Shakespeare's *Lear* and Sophocles' *Oedipus*

7. Martín Esslin, op. cit., p. 150.
8. Op. cit., p. 153.

faced with total despair and the absurdity of their human condition? And yet their tragedies become liberating experiences. Ionesco's questions imply his desire to be considered a rediscoverer of buried traditions. But though Ionesco does not destroy Western traditional institutions, like some writers, the probability that he is an offshoot of Aeschylus and Shakespeare is rather remote. For his agnosticism and tolerant atheism interfere with a belief in the very values he is trying to restore.[9]

In the field of the Theater of the Absurd, Jean Genet attains a certain prominence. Surrounded by constricting rituals, he traverses burned out spiritual deserts, since "in a very real sense his theater is a Dance of Death"—as Jean-Paul Sartre writes in describing the playwright in his famous *Saint Genet.* Sartre's disciples claim that it is "one of the major critical works of the twentieth century which has exerted an infinitely greater influence than its subject."[10]

Genet's desolation and loneliness stem from his deprived childhood—abandoned at birth in the Maternity Hospital of Paris, brought up in hospitals and jails—and it apparently branded his life and his work with a mark of evil. Suffering from the tension of inner anxiety, he seemed driven by a constant search for the absolute, for some sacred element. Genet operated in a system of inverted values "where evil is supreme and the most beautiful flowers are soiled by excrement and sordid crimes."[11] A ritual assassination, for example, is dramatized as an integral part of his play *The Blacks.*

Though his plays are undeniably a form of social protest, there is no proselytizing or propaganda. His theater falls into the category of the Theater of the Absurd by virtue of being unconventional in its character and motivation and by abjuring the usual development of a narrative plot; instead, he tries to disturb the audience by confronting them with a bitter and

9. Christian Chabanis, *Existe Dios? No . . . ,* Buenos Aires, Hachette, 1976. Herein, E. Ionesco, C. Levy Strauss, Roger Garaudy, Raymond Aron, and others confess their atheism.

10. Martín Esslin, op. cit., p. 166.

11. Op. cit., p. 169.

cruel world. Baudelaire's aristocratic pleasure in shocking is equally apparent in Genet.

Interestingly, the bourgeoise society that is belittled and despised by the author in its snobbery, admires and praises the very thing that threatens to kill the values it would defend. The link of the Christian world with a society that admires, or at least tolerates, this deep degradation of its faith is terribly fragile. For the plays, as Genet himself states, are not made to entertain. And so, what are they for?

Sartre, in analyzing *The Servants* (in his *Saint Genet*), points out that the lady of the house and her lover represent the respectable side of society, the world of the just, from which the derelict Genet has always felt excluded, shunned like a monstrous creature. "The rebellion of the servants against the masters is not a social act, a revolutionary deed; rather it is tinted by a certain nostalgia, a yearning, a rebellion like that of Satan, the fallen angel, against the world of Light from which he is forever exiled. This is why the rebellion is expressed not as a protest but as a rite. Each servant in turn plays the part of the mistress of the house, thus expressing her desire to be the actual mistress; and each plays the part of the servant as well, a progression from adoration and servility, to abuse and violence. It is the discharge of all the hatred and envy of an outcast who sees himself as a rejected lover. This ritual is a kind of Black Mass."[12]

In Esslin's words: "The concept of a ritual act, a magical repetition of an action stripped of reality, is the key to an understanding of Genet's theater." Esslin also transcribes a letter by Genet addressed to the editor Pouvert which is used as a preface to one of the editions of *The Servants:* "On a stage similar to ours it was necessary to reconstruct, on a platform, the end of a supper [he refers to the Last Supper]. Using this point of departure, and it is difficult to find anything else, modern drama for 2000 years has found its highest expression, day after day, in the sacrifice of the Mass. The point of departure disappears under the profusion of symbols and ornaments . . .

12. Op. cit., p. 165.

An act that did not take place in my soul would be vain . . . There is no doubt that one of the functions of art is to substitute for religious faith an effective beauty. This beauty should at least have the force of a poem, that is to say, of a crime. But let us leave that aside."[13]

With these notes one can proceed to grasp the character of Genet's theater. His play *The Balcony* presents an important step on his chosen path. Here he attempts to imbue his ravings on sex and power with the solemnity and splendor characteristic of a liturgical service in a great cathedral; "but the play should be vulgar, violent and in bad taste. My work ought to become the world's most shameless prostitute.

"The opening scene of *The Balcony*," Genet continues, "shows a magnificently attired bishop giving a discourse using highly theological language. But as soon as we perceive that we are in the presence of a bishop, it becomes brutally clear that it is not an episcopal residence at all but a brothel and that the character in question is not a bishop but a worker for the Gas Company who paid the madame of the establishment so that he could give free rein to his fantasies about sex and power. Madame Irma's brothel, the Great Balcony, is a palace of illusions, a labyrinth of mirrors where men can make their secret fantasies come true: they can envision themselves as a judge punishing the rapists of young girls, as a general beloved by his favorite horse (who is a lovely girl), as a leper miraculously cured by the Virgin, as a dying legionnaire attended by a beautiful Arab maiden. In the brothel of Madame Irma, they can find solace for all their repeated fantasies. It is a mirrored maze, not only in the metaphysical, but in the real sense as well; these mirrors multiply the image of the self-hero everywhere. It is a kind of theater that is directed and staged by Madame Irma.

"The plot of the play revolves around the fact that the country where The Great Balcony is located is going through a painful revolution. In the opening scenes bursts of machine gun fire are heard. The revolutionaries want to overthrow the established power which is represented by a virtuous and re-

13. Op. cit., p. 166.

mote queen, and her judges, bishops and generals. The palace is stormed, the queen and her court are swept away. An emissary from the palace arrives at The Great Balcony with a message. The battle can only be won if the populace can be made to believe that the old symbols of power are intact. Are Madame Irma and her clients—the judge, the bishop, and the general—willing in all seriousness to assume the roles of the queen and her court? Madame Irma and her clients agree. Very solemnly they appear on the balcony before the masses. The revolution is quelled, but the 'bishop,' the 'general,' and the 'judge,' who now have to exercise their powers in real life, are tired, and they yearn for their former fantasies.

"Clearly the play takes place in the world of fantasy, in Genet's dreams of the essence of power and sex, which for him have the same roots, in his fantasy-wish, over the real nature of judges, policemen, officials, and bishops. The young man who was ostracized by society and who has since rejected all its laws, unable to understand man's purpose in the coercive workings of the state, spins a fantasy about the motives of those men, the instruments of the state. The outcast comes to the conclusion that these men, these officials, act as they do because they are driven by a sadistic lust for power; and they use the sumptuous symbols of their office—the ceremonies and rituals of the royal court, the military establishment, and the church—for the sole purpose of consolidating their own power.

"Genet tried to find a way to escape his loneliness and the oppression he feels at his failure to do so; and thus, by using a substitute explanation for the myths and fantasies, he attempts to restore to the world some meaning and purpose, but they are condemned to fail again and again.

"Ceremonial and ritual theater," Esslin concludes, "like Greek drama, presupposes a valid and live body of mythical doctrine. And this is precisely what is lacking in our civilization. Therefore, Genet is obliged to construct a trap that will offer a reasonable basis for ridiculing liturgy. However, he has not totally succeeded in this integration of plot and ritual."[14]

For this very reason we feel that the influence wielded by

14. Op. cit., p. 170 and ff.

the Theater of the Absurd is tremendously destructive. In some rare instances it may, on the surface, appear to be redeeming. When *Waiting for Godot* was staged at the San Quentin penitentiary before 1,400 inmates, they felt that it was their drama being shown and that their only hope was not to hope at all.

But can this argument extend to all society? Should collective mankind feel like the inmates in San Quentin prison? It is extremely hard to answer in the affirmative.

For those interested in knowing the origin of the many manifestations of cruelty in our own times, it might be helpful to take a brief glance at the work of Antonin Artaud, a very popular writer among young intellectuals.

Artaud preaches with vehemence the need, in *The Theater and its Double,* for a return of myth and magic, for a cruel and pitiless expression of the conflicts in the human mind, for a Theater of Cruelty.[15]

"All that which functions is cruelty," Artaud writes, "and theater should be constructed on the idea of extreme action, raised beyond its limits . . . Theater restores in us our latent conflicts with all their powers and gives these powers, which we perceive as symbols, names, and behold! before our eyes, a battle of symbols ensues, since theater can only become theater the moment the impossible truly begins and the poetry of the stage sustains and enlivens the symbols presented."[16]

These words eloquently trace the outline of the path along which the new theater is progressing. One has only to think how the negative aspects innate in man since the Fall are stimulated, and about the kind of shortcuts to man's redemption that are offered by it.

Some other thoughts of Antonin Artaud are worth noting: "Creation and life itself can only be defined as a sort of rigor, and therefore a fundamental cruelty that, at whatever cost, sees things through to their inevitable end."[17]

15. Antonin Artaud, *El Teatro y su doble,* New York, Grove Press, 1958, p. 7.
16. Op. cit., p. 28.
17. Martín Esslin, op. cit., p. 290.

It has been said that subversion starts with the subversion of language. Artaud says: "In my opinion clear thought in the theater, as everywhere else, is finished, dead." This is yet another very small but valid sample of how youth is being swept up by the environment of culture, later to be thrust into the political. We feel that too few true lovers of freedom have fully measured the indelible and effective connection between the theological, the cultural and the political. Marxist minds are constantly conscious of this, and they use their creative qualities to their utmost to undermine our heritage.

This can be seen in the disquieting writings of Trotsky. In his *Literature and Revolution*, the theoretician and promoter of the October Revolution in Russia in 1917, evinces his thorough understanding of the artistic movements of his country and the mentality of its artists—their politico-religious inclinations, even their personalities—which he needs to determine whether they would be useful to the revolution, useful idiots, or inclined to offer resistance. Trotsky dealt intelligently and forcefully with each one of these groups, thus insuring his political success.

In order to keep theology out of the Marxist dialectic, he cleverly ignored it. Even now, in whatever the field, one can eliminate the unwanted through silence. Trotsky, of course, like Lenin, knew perfectly well the relationship between the three levels.

After concurring with everything discussed above in an interview in March 12, 1976, with the *ABC*, the Madrid newspaper, Professor Augusto del Noce, rector of the Department of Philosophy of Politics at the University of Rome, spoke of the aims of Eurocommunism and stated that its goals are to conquer culture. The conquest of power can no longer be achieved by traditional revolutionary means. Civil society must first be conquered, and then the state will collapse.

And how will the conquest of culture come about? "By means of an alliance with middle-class intellectuals, with radical movements, with Catholic progressives and, most especially, with all the trends of modern Catholic theology. . . ."

"In Italy," Professor del Noce continues, "all the essentials are under control: the publishing houses, the schools, quite a

few universities, the judiciary . . ." The confrontation in the fight to dominate the sources of culture is not between "the proletariat and the bourgeoisie" but between "tradition and modernity."

The professor continues to say that on matters of cultural programing, the Italian Communist party maintains an attitude of evasion toward the more controversial issues; it never defines its position on key questions. Instead, broader questions of historic and practical appraisal are put forward that imply a more general concept of life, the Marxist concept. These appraisals, says the professor, must be accepted as true, because they are "anti-fascist."

Both Gramsci, the founder of the Italian Communist party and a close friend of Trotsky, and Berlinguer, who follows in his footsteps, feel that political leadership presupposes a cultural leadership. A new culture and a new system of values are created precisely so that the freedom of ideas may be redefined. Gramsci also understood that the only hope of eliminating the Catholic Church was to undermine her and destroy her from within. Today's neomodernist and demythified theology was foreshadowed in Gramsci's thoughts at the beginning of the century. Knowing that Marxism and Catholicism are incompatible, he sought a compromise because he knew that the appeasers would end up in apostasy.

More than half a century ago Gramsci wrote that these groups would "amalgamate, organize, vivify and finally commit suicide." Paradoxically, his prophesy coincides with that of Pope Pius X, who in answer to a priest who wanted to refurbish his church, said: "Friend, if you do this, you will not get those on the outside in, but force those that are inside out."

The "cultural" tactics of the Italian Communist party depend strongly on the bourgeoisie, including big business. This support together with their cultural infiltration have brought them millions of votes. One wonders whether this sort of thing is not occurring everywhere in the Western world, since the forces, allied as they are to modern culture, appear to crop up everywhere as instruments of a new cultural *risorgimento,* inseparable from an *aggiornamento,* which as we shall see later, is also cultural.

108

An interesting episode, relevant to practical politics, occurred during the election of Professor Giulio Carlo Argan as mayor of Rome in June of 1976. Professor Argan was the director of Contemporary Arts in the University of Rome, the president of the International Association of Art Critics, and a member of the Congress of Modern Architecture. He wrote an article on his political platform for *L'Unitá,* the literary organ of the Italian Communist party. In it he said that "Rome must be liberated by decentralizing the lower-class bourgeoisie bureaucracy, which is ignorant, presumptuous, conformist, conservative, and which the city drags behind it like a ball-and-chain. It must be liberated from the nefarious pretension of being a city different from other cities: 'sacred, universal and eternal,' imbued with a charismatic spirituality."

This immense project, as outlined in the article, would come about by a complex intermingling of cultural, social, and historical elements (surpassing mere aesthetic manifestations), based on theological—in the negative sense—and political principles. A considerable portion of the article concerns the new cooperation between the artistic and technological activities of contemporary civilization. Argan has written an admirable study of modern art.

This brings to mind Sophocles who, for his work *Antigone,* was honored by the citizens of Greece by receiving the appointment of *strategos,* or defender of the city. In the play the heroine dies while defending the unchanging and sacred laws of the city. Moreover, Antigone tells Creon, king of Thebes: "I did not believe that your decrees, you being a mortal, could have primacy over the unwritten, immutable laws of the gods. Those laws are not of today or yesterday; they have always existed."

Mayor Giulio Carlo Argan may find it rather difficult to erase the sacred character of the city of Rome. If he were to succeed, the apocalyptic trumpets would already be sounding. In the artistic sphere the true answer would be to relate it to the sacred, since this cooperation has in the past produced the most sublime works.

"Every liturgical celebration," writes Charlier, "since it is the work of Christ the High Priest and his body, the Church, is

109

the highest sacred act, and its efficacy cannot be equaled by any other liturgical act with the same degree of intensity. The liturgy displays the entire sacred drama and it requires the participation of all the arts. Architects, sculptors, painters, have all constructed and beautified the temple. Efforts to degrade churches to the level of barns or tin-roofed huts demonstrate a total lack of consideration for our sense of beauty that is implicit in the liturgy, and would deprive the soul of its deepest thirst.

"The music that carries the Sacred Word has always used as a noble instrument the human voice of the Christian people. In the Gregorian period there was no need of the organ to shake the vaults of the temple. Instead a common chant filled the spaces as liquid fills a wine glass.

"The mystery of the altar is true unto eternity; this is why the liturgy was created with the most precise ordinances. The writer Mallarme, himself an unbeliever, recognized that the liturgy embodied the perfect drama he had always dreamed of."[18]

Liturgy is theology made tangible for the soul of the faithful. That is why artistry in the surroundings is so necessary.

One ought, really, to take a brief glance at the interesting evolution of the relationship between art and the Church, or better said, the accomplishment of sacred art, in order to understand what brought about such liturgic-artistic works as the popular *Misa Criolla* or the aberrational *Misa Tanguera*.

The best source can be found in a book by the illustrious Abbot of Maria Laach, Ildefonso Herwegen, who dealt with the subject in depth and with an enlightened sense of history.[19]

With the advent of Christianity, the new convert for the first time felt an inner assurance "that raised the Christian above all the miseries of the time, and gave him power to sacrifice self and remain loyal to Christ until death," Herwegen writes.

18. H. y A. Charlier, *El Canto Gregoriano,* Buenos Aires, Areté, 1970, p. 34.

19. Idelfonso Herwegen, *Iglesia-Arte-Misterio,* Madrid, Ed. Guadarrama. Colección: Cristianismo y hombre actual, 1973, p. 75.

"This deep emotion had to find a way to express itself. It found it in art.

"Art became the jubilant language of the soul," he adds. It did not reject the art of the ancients, often symbolic and nobly conceived, but it filled them with new content. For it is the spiritual and supernatural content of art that distinguishes it from the pagan. Primitive Christian art had a symbolic character of its own. Herwegen distinguishes between the demonstrative and the objective symbols in art. The former, he maintains, "point to a more lofty spiritual reality and thus attempt to draw transcendental realities nearer to conceptual and earthly intelligence. Modern man only knows this meaning of symbol. But the objective symbol places invisible and supernatural reality within real existence, making it visible and palpable in this world." The Christian mysteries are symbols of this type.

It is claimed, with good reason, that the paintings in the primitive catacombs preserve the signs of objective symbolism, though later on Christian imagery tends to be demonstrative. Eastern Christianity has better preserved this symbolic quality.

"The anchorites of the Heraclean caves," the abbot writes, "saw the image of the Pantocrator not as a representation of a historic fact, not as dogmatic doctrine, but rather as a means of contemplating and worshipping God." Western art has progressively shown a greater propensity to portray the effect on man of the Mystery of Christ and its psychological consequences. As Herwegen clearly demonstrates, this can be observed in the evolution of the portrayal of *The Last Supper* through the centuries.

By the time of Dürer in the sixteenth century, the idea of mystery had disappeared. This prompts Herwegen to declare that "the soul of Eastern Christian art is mystery; that of the West, ever since the Middle Ages, is an individual devotion which is profoundly psychological." Paradoxically, Eastern art has been labeled sterile and lifeless; its sublime serenity, linked to an inner fervor, has not been recognized, but the neglect is currently being corrected.

111

What is happening to the liturgy? "In the framework of liturgy," Herwegen writes, "which consists of words and actions objectively designed, there takes place the moving encounter of God and man, of nature and grace. It is the supreme experience of life, it contains plenitude, dynamic but firmly restrained in a monumental static. The more intimate the ties between art and liturgy, the purer and greater will Church art emerge from the present crisis which has been brought about by the rationalist ideology and an excess of psychology. It should and will emerge as communal Christian art whose brilliance shone once, though primitively, in the darkness of the catacombs as a reflection of the sacred mysteries."

Will liturgy, wedded to folk music as in the *Misa Criolla* or to the tango as in the *Misa Tanguera,* be able to resuscitate Christian art and make it communal art, the art of the people? The concept of "popular"—also associated with catacomb art— is correct but only in a special sense, for it is never opposed to theological directives in art. The paintings of the catacombs are not popular in the strict sense, because they are not the product of the mass consciousness. They stem from the teaching and catechesis of the Christian dogma. Moreover, since teaching was closely connected with the celebration of the mysteries, its functions go beyond the purely intellectual and become an experience that affects the whole man, involving his understanding, his will, his sensibilities. In celebrating and living the mysteries, Christians became familiar with their spiritual and ideal content, as well as with the theological doctrine, through simple formulas. Painting was not the least of the contributions to the popularization of liturgy.

It is necessary to explain the concept of "popular" even further so as not to be victimized by widely accepted but erroneous teachings. Gustave Thibon, in a weighty article entitled "Pueblo y Cuadros Dirigentes" ("People and Authority"), invites us to consider the following:

"There is a tendency," Thibon writes, "in everyone to save and regenerate everything as there is to debase and destroy everything. The two currents cross in a nation's soul. One aims

112

at dissolution and anarchy and is self-sufficient; the other is profoundly rich but is incomplete and, as it were, germinal. In order to come to be, the latter is constantly forced to appeal to a superior force. With Barbusse we believe in the 'depths of the people,' but on the condition that these depths be illuminated and nourished from the outside, from above. For the abyss between the two can either create or devour everything.

"And democracy—the word itself indicates that there is nothing above the people, that the people stand alone—has devoted itself for far too long to cultivating what is base in the people, leading to their self-destruction. That is because the people have resigned themselves to failure rather than to progress."

Barbusse's statement sheds light on what has been previously written concerning popular art. And it tells us why the celebration of the sacred mysteries set to the sensual rhythm of the tango or folk tunes is a spiritual denigration that should shock us.

Ariel Ramírez, the folklorist who actively participated in the composition of the *Misa Criolla,* has a past that casts some doubts on his Christian spirit and places him close to the circles that promote the indigenous type of music that is so often politically manipulated. His non-Christian sensibility has given us in the *Misa Criolla* a mishmash of rhythms that is not only an insult to Church decorum but to good taste as well.

Fresh folk melodies—fewer nowadays—have manifested the elemental in the natural and temporal sphere of the soul of the people. But when the melodies are taken out of context and inserted into the sphere of the sacred, they no longer fulfill their primary function. They become obscured and meaningless and often cancel themselves out on both levels—the liturgical and the popular, the sacred and the profane. Nothing justifies the supplanting of liturgy with this kind of folk song.

Apparently there are not enough priests left who are capable of raising the people to a higher level, which confirms Gustave Thibon's theory. The incredible inability of so many priests to

113

comprehend the sacred and the supernatural leads us to doubt their ability to guide, educate, and instruct the people in a truly Christian manner.

Francisco Javier Vocos warns that "attending church services should not be considered as a sentimental satisfaction or an enhancement of personal emotions, or a mere practice of chants, readings, and participation which pleases or flatters the congregation. It is not a matter of entertainment nor paying homage to oneself. Religious symbols and acts are not intended to transmit sentimental effusions. They are meant to establish a relationship with the mystery which illuminates the mind and touches the heart. None other than the Church, aided by the Holy Spirit, can establish the quality and adequacy of the symbols which, when properly contemplated and perceived, have the power to inspire devotion."[20]

True to the saying "Lex orandi, lex credendi" ("As one prays, so does one believe"), the following news item well illustrates the way the new Church is being constructed through liturgical changes. It was published in *Siete Días* in an article entitled "The Campaign of the New Church."

"While the Jesuit priest Van Kilsdonk, 53 years of age, is getting ready to perform a marriage ceremony, the organ of the Church of St. Ignatius Kollege in Amsterdam is playing the latest hit by Sandie Shaw, 'Puppet on a String.' Wearing a long grey cape that reveals his dark suit and sky-blue sports shirt, the priest receives the couple. The groom wears a morning coat, grey gloves and a top hat. The bride's fair slim figure shows beneath her veil. She is a Catholic and he is an atheist. The guests sing during the ceremony and the betrothed couple exchange smiles and kisses. Then the bride climbs the stairs to the pulpit and reads from an epistle of St. Paul. Afterward comes the solemn moment, the customary exchange of vows. Father Van Kilsdonk embraces the newlyweds and commands them: 'You shall promise to raise your children in the spirit of the Gospel not "of the Catholic religion" and you will see God

20. Francisco J. Vocos, *Liturgia y Folklore,* Buenos Aires, Revista Roma, 1977.

114

in each other's eyes and nowhere else.' And he insists, 'Listen carefully, nowhere else!' Then he invites the friends of the couple to communion. He pours the consecrated wine into a goblet shaped like a chalice, and breaks the bread giving the halves to the couple. The groom's confirmed atheism does not seem to impede his participation.

"In Holland, the 'aggiornamento' includes all the aspects of the liturgy and enjoys the support of the Catholic hierarchy. Cardinal Alfrink, the primate of Holland, and Monsignor Hendrikse, bishop of Utrecht, have decided to give firm support to the initiative of the clergy and the youth who are striving to institute a new ceremonial more in accordance with the times.

"Recently, a Sunday Mass was celebrated in a theater in Utrecht. To a setting of swinging rhythms sung by the faithful, accompanied by the twanging of electric guitars and a set of percussion instruments, the bishop presided at a Mass for a thousand teenagers. As the Mass came to an end, the last echoes of a modernized Agnus Dei still lingering, the Dutch prelate explained that 'the Church has to adapt itself to the times. Naturally, we cannot replace Bach's Toccata in D-Major for the latest hit by the Rolling Stones overnight. We must proceed slowly. The future will tell whether my method is right. Personally, I am satisfied, for we have regained a majority of the Catholic youth who had forgotten about the Mass.'

"Although they remain a minority, the preconciliar Dutch reactionaries have, of course, raised their voices against the 'pop' Mass. They say that 'the din of the electric guitars and the percussion instruments interferes with the meditation and prayer at the moment of Holy Communion.' Convinced as they are that modern music is an instrument of pleasure rather than a stimulus to faith, these detractors conclude: 'nowadays the young go to Mass as to a spectacle.'"[21]

It is obviously unnecessary to comment on the phenomena of the last two decades, along with the various ways in which the traditional Mass has been prohibited. But it raises the pos-

21. *Siete Días,* Buenos Aires, Argentina, Dec. 20, 1968.

sibility of a variety of churches springing up at a time when there is constant talk about the need for unity.

A tremendous demagoguery proliferates in the modern Church which takes no account of the needs of the soul, as with the spiritual pap of the *Misa Criolla,* the *Misa Tanguera,* and so on. "This is what the people need," we are told by our high church officials.

What a divergence from the true joys of the spirit!

Charlier said that if we defend Gregorian chant, it is not because of an affinity for the archaic or for a ridiculous aestheticism. It is because the Gregorian chant is the most accomplished expression of Catholic spirituality in the musical arts. Today's officials try to create a modern spirituality, or rather, a pseudo-spirituality, which is more accessible to the masses, but it is "accessible" only in that little attention is paid to raising the faithful above the material to the level of the supernatural.

Obviously, Gregorian chant is not like nature's voice. It speaks of things that no human voice dares mention, of a nostalgia for the lost homeland, of the longing for an unattainable perfection, of the desire to see God, as Charlier would put it. And Gregorian chant *is* accessible to the ordinary man. He can learn to understand and love it because it is a marvelous medium of education, awakening the soul to the eternal realities. It is the faithful who will save it from oblivion.

Charlier writes of Gregorian chant: "It is not a matter of writing a musical commentary on the text, it is rather the attainment of its total transparency, its inner light, and its sacred character." [22]

Are we not losing the sense of the sacred by the use of words? This might explain the decline of vocations and the proliferation of certain types of literature, painting, and music, so idolized by the younger generation.

Even the seminaries, where future priests are educated, often propagate these subversive kinds of art, and without the slightest critical hesitation. But in an epoch like ours, an epoch of obvious spiritual decadence, it is imperative that the

22. H. y A. Charlier, op. cit., p. 143.

most sublime arts be restored to the liturgy. From there, architecture, sculpture, writing, and music will radiate out to the people and help them find those timeless values which lie on a deeper and more meaningful level.

Finding and appreciating valid art works does not mean to discover only those works that contain a conception of God, of man, and of the cosmos. They must also be convincing in their artistic value. If the works that meet these criteria still fail to interest man's soul, it is because a series of powerful but unstable influences are interfering with the process of appreciation.

To these exterior influences we can add some inner ones, since the enemy lurks within us all—the absence of a discriminatory aesthetics sense and a propensity for showy snobbery. This type of snobbery leads the younger and even the older generations through muddy paths of despair and resentment which, in turn, lead to the absurd, and a breeding ground for violence, so widespread nowadays.

Many parents are surprised to hear that their offspring profess a Marxist or some other bizarre ideology. But few of them ask themselves how these children come to hold and defend such ideas. They may frequently have seen their children reading a widely acclaimed book, listening to "popular" music, gazing at the latest painting—all of which succeed in "converting" the young. And if the elder generation escapes it is by inertia as much as anything else.

We have hope for the future, because we foresee sufficient strength and grace in our faithful young to reaffirm tradition, to redeem the errors of their elders, and to prepare a world of genuine perseverance in the stand for the Good, the True, and the Beautiful. But the battle will not end until the last heartbeat.

Index

123

DATE DUE

NOV 8 '93			
JAN 3 PAID			
APR 2 9 1996			